ART ATTACK

A SHORT CULTURAL HISTORY OF THE AVANT-GARDE

ART ATTACK

A SHORT CULTURAL HISTORY OF THE AVANT-GARDE

MARC ARONSON

CLARION BOOKS / NEW YORK

CLARION BOOKS
a Houghton Mifflin Company imprint
215 Park Avenue South, New York, NY 10003
Text copyright © 1998 by Marc Aronson

Text is 13 point Bembo.
Book design by Sylvia Frezzolini Severance.

Printed in the USA

Library of Congress Cataloging-in-Publication Data
Aronson, Marc.
Art attack : a short cultural history of the avant-garde / by Marc Aronson.
p. cm.
Includes bibliographical references and index.
Summary: Discusses the arts, life styles, politics, and fashions while tracing the story
of bohemians, radicals, hipsters, and hippies from Paris in the nineteenth century
to contemporary America.
ISBN 0-395-79729-2
1. Avant-garde (Aesthetics)—France—Paris—History—19th century—Juvenile literature.
2. Avant-garde (Aesthetics) France—Paris—History—20th century—Juvenile literature.
3. Arts and society—France—Paris—Juvenile literature. 4. Avant-garde (Aesthetics)
United States—History—20th century—Juvenile literature. 5. Arts and society—
United States. [1. Art, Modern. 2. Art appreciation. 3. Arts and society.] I. Title.
NX180.S6A67 1998
700'.411—dc21 97-22372
 CIP
 AC
CRW 10 9 8 7 6 5 4 3 2 1

FRONTISPIECE
Nam June Paik builds artworks out of televisions, treating them as objects and color
sources. Instead of transmitting art, they are art. Here is his T.V. Cello, created in the 1970s.
(66" x 41" x 48". Courtesy the artist and Holly Solomon Galleries.)

CONTENTS

ACKNOWLEDGMENTS

Many friends and scholars helped me to refine my ideas and improve this text. Jerrold Seigel, whose specific contributions I cite in the notes, is my model for a historian of the avant-garde. I learned how to read and write cultural history by studying with Thomas Bender. I am grateful to Avis Berman, Sara Bershtel, Eliza Dresang, and Rochelle Gurstein, all of whom read entire draft manuscripts and supplied key corrections and insights. My understanding has been raised exponentially by their efforts.

Riva Hocherman, Friederike Paetzold, and Sharyn November lent me both music and insights that made punk comprehensible. Bruce Brooks allowed me to understand the modern world of sampling. Philip Ashley described the inside of Electric Lady studio. Martin Fisher and Martin Mullin of MMFAS became real collaborators as they provided expert photo research that went far beyond the call of duty. My mother, Lisa Aronson, was a constant source of ideas and references and took time out of a trip to Zurich to seek out and photograph the Spiegelgasse.

When I thought of this book I imagined that Dorothy Briley would be the best editor for it. I was right. She believed in this nearly impossible subject and with Dinah Stevenson and Jennifer Greene made it possible to turn it into a book. Despite all of this good-natured advice, the judgments, and errors, in this book are entirely my own.

My introduction to the avant-garde came at a very young age when my father, Boris Aronson, took his reluctant son to see a Brancusi show. Whatever appreciation I have of art and society, and the value of radical art, came from him. This book is my long-delayed gift to him. But it would have been impossible to make that gift without Marina Budhos.

To my father, as the past that formed me, and to Marina, my future, I dedicate this book.

Pavel Tchelitchew's *Hide and Seek* was painted between 1940 and 1942. This brand of surrealism plays on the fears and ghosts just at the edge of our conscious mind. In the fifties and sixties, a more popular version of this style of painting often appeared on the covers of paperback science fiction novels. Today, novelists such as Stephen King explore a similar borderland of indwelling terror.

(6' 6½" x 7'¾", oil on canvas. Courtesy the Museum of Modern Art, New York. Mrs. Simon Guggenheim Fund.)

We live in the most confusing period in human history. In the past two hundred years we have made more advances in science, industry, medicine, democratic government, and the status of women than in all previous centuries combined. At the very same time we have carried out the worst genocides, caused the most ecological destruction, and inflicted the most grinding and relentless poverty ever seen on this planet.

Every day brings startling examples of "progress"—new computers, new vaccines, new insights into the structure of the universe. And every day we see horrifying evidence of our capacity to be ever more cruel, heartless, and destructive. From the early 1800s, when artists first began to sense this terrible rush of newness, they tried to make sense of it. This is their story, and yours.

In the army, the advance guard is the first wave of soldiers who rush into enemy territory, risking their lives to map out the terrain. In the arts, the avant-garde are people who have devoted their talents, even their lives, to seeing the future and to confronting us with their visions. Often, it is young people, teenagers, who take the greatest risks, who see the furthest, and who make the most challenging art. This is the story of risk takers, of their creations, and of the times in which they lived. It is about art that changed how we could imagine the world and about the world that made that art possible. This history is littered with self-destruction, sellout, and silliness. And yet it is also the history of the great art and the great issues of our time.

The idea of an artistic avant-garde began in Paris in the 1820s, just when people began to see that industry, cities, and science were totally transforming their lives. It made sense that experimental art looked new and unusual; newness was everywhere.

On the streets of the city sensitive poets watched surging crowds of strangers—and found the anonymity liberating. In huge, inhuman factories the sons of farmers lived grinding, clock-run lives their parents couldn't imagine. Yet daily the newspapers announced amazing inventions that proved we were wresting secrets from the gods and gaining world-altering powers.

Artists tried to expose the hidden dangers and broadcast the new possibilities of this dawning new world. In 1825 the utopian socialist Henri de Saint-Simon wrote that "it is we artists who will serve you as avant-garde. . . . We wish to spread new ideas among men, we inscribe them on marble or on canvas." From the first the avant-garde was political. But that was only half of the story.

Not only was life changing, so were the ways of experiencing and recording it. Before the nineteenth century there were no photographs or films, before the twentieth no radios or televisions or computers. Even time was different when "horsepower" was just that. Since no one moved all that rapidly from one place to another, there was no need for standard time. Each town set its clocks by the sun and labor followed the rhythms of the days and seasons. To see how far away we are from that world, just turn on your television.

Today, a music video that jumps from image to image seems normal. We are familiar with the technique, and the rapid changes match our own channel-hopping, endlessly fragmented lives. But that style of art and our enjoyment of it are quite recent developments, and both are the gifts of the avant-garde. Treating our most hidden sexual desires and our most disturbing destructive urges as art comes to us directly from the path-breaking artists of the last two hundred years. Music that is painfully loud, filled with dissonance, and played on electronic instruments was invented by underground artists long before rock 'n' roll was born. Most generally, we see life as a set of jagged flashes, not a smooth continuous development, because of the experiments of the artists in this book. We could not make sense of thirty seconds of MTV without the avant-garde.

Because avant-garde artists seek to be ahead of their time, their work is often deliberately disturbing. Nudity, explicit sexuality, provocative or purposeless acts, and rage are commonplace. Shocking the bourgeoisie (average middle-class citizens) is

one of the great joys of such artists. This extends well beyond art: avant-garde artists frequently disdain conventional morality and support socialist, Communist, or fascist political movements. They may even advocate random acts of violence.

To be in the avant-garde is to be in a perpetual state of rebellion. That can be a very creative state of mind. At its best, the avant-garde makes visible on-stage, in print, and on canvas the hidden thoughts, the deepest yearnings, and the dawning conflicts of our time. Through it, we are plunged into the dreams and nightmares that churn just below the surface of average everyday life.

The avant-garde, you might say, explores the frontier of mystery, the borderland that begins where what we know ends. There are basically two ways to get there. A person can journey inward—following images, senses, and impulses, no matter how strange, disturbing, or bizarre. Artists who take that trip sometimes use meditation, mysticism, drugs, sex, or even self-mutilation to induce ever more intense visions. They then must decide how to turn what they find into art, unless they consider the very quest a form of art. Or a person can turn the rebellion outward and create art that confronts the rigid rules, outdated morals, and repressive structures of society. These artists use art to attack entrenched political systems or to expose smiling hypocrisy. Avant-garde artists who seek social change typically write manifestoes, attack comfortable audiences, and are only too pleased to be condemned by the authorities. For the inner artists, newness lurks in dreams. For the activists, it will arrive with a new society.

These two radical pathways point out the crucial link between being an avant-garde artist and being a teenager. Adolescence can be an extremely intense period of physical and emotional change. Teenagers often feel out of place and misunderstood. The routines of the dinner-table, class-bell, *TV Guide* world can seem shallow, false, even oppressive. Faced with this sense of difference, teenagers often follow one of two paths: inward, toward the strange and personal world of sense, fantasy, and impulse; or outward, to provoke, challenge, and reshape the world. These are precisely the paths of the avant-garde explorers. That is why many avant-garde artists flourish in their teens and early twenties and why people that age are so sensitive to their art.

When you think of the inner and outer paths,

one great split in the avant-garde is immediately obvious. If the avant-garde attempts to show new life in new ways, what are its obligations to social problems? Shouldn't new art be devoted to fixing the harms of modern life: the exploitation of workers, the devastating consequences of prejudice, the oppressive rules of greedy bosses, dictatorial governments, rigid moralists? But art about social problems is often quite traditional—paintings that show injustice, statues to heroes of resistance, hymns to great causes. Can this really be the new art for new times? A boring statue is a boring statue, whether it shows an ancient general or a modern radical. And what kind of freedom, what kind of liberation, is there if artists are told what to make, and how?

For many avant-garde artists, then, form is more important than subject. They see all types of traditional art—poems, novels, plays, paintings, sculpture, songs, scores—as dated, boring, useless. They demand new kinds of art that are as novel and startling as science or fashion or war. If we live in disturbing times, they insist, our art must be just as unsettling. But, some ask, what does that achieve?

If great artists create works that offend, threaten, and alienate everyone, won't everyone reject them? If only wealthy collectors or elite critics can appreciate these works, what use are they to anyone else? Can art be radical in its politics as well as its form? And what is art anyway? Perhaps a deviant, unsettling, or eccentric life-style is itself a form of art. Maybe living outside of the rules is the only art for our times.

More recently, these questions have taken an even more paradoxical turn: when shocking art becomes popular—think of a rock band that parades its Satanism, tattoos, and deviance to huge crowds—has it lost its edge? Is it new like the wild world around it or just another compromise, another drug that blinds us to the real challenges of our time? Are those who get the clothes, hair, and slang right—but who are secretly conventional—truly avant-garde?

There is no single answer to these questions. In this history you will see them arise again and again. More than any solution, it is this debate, this roiling ferment, that is characteristic of the avant-garde. Which is as it should be. The history of the avant-

garde is filled with inspiration and insanity, frenzy and fraudulence, genius and betrayal. That is exactly why it is so important: in its gruesome failures and its spectacular successes it is a perfect reflection of these most terrifying and most exhilarating of times.

NOTE TO THE READER

We live in a multimedia age, and no subject is more suited to that kind of presentation than radical art. But this is a book with black-and-white illustrations. I have chosen that form for two reasons: it is the best way to reach the most people, and you can use the book as the hub of a multimedia experience. In each historical section I have listed music that you might want to listen to as you read. Most of these selections are available in libraries and music stores. The selections last longer than it will take you to read the text, but you can return to them at your leisure as you look at the art. The artwork that appears here in black and white is beautifully reproduced in full color in art-history reference books, on CD-ROMs, and on many different sorts of Web sites. Major museums throughout the country also exhibit the pieces. Though I have chosen not to discuss avant-garde films I have listed a few films and documentaries that are particularly good at giving a feel of a specific time and place. Also keep in mind that there are extensive notes at the back of the book that give the sources for everything I discuss. To get the full effect of each section, then, you have to do a little extra work. That is good. It suits avant-garde art, which always seeks to challenge its audience. This is a book, like any other, and it is a multimedia treasure map. It is up to you to decide how you want to use it.

A *Nude* in New York

Scott Joplin's ragtime compositions are an appropriate score for this section.

New York, February 17, 1913

The press buzzed with warnings. Readers of staid Sunday papers puzzled over distorted paintings of a tipsy-looking skyscraper. This crazy new art was "explained" in interviews with a French painter named Francis Picabia, who only made things more confusing. He claimed that art was no longer supposed to look like anything, it was the painter's "impressions" that counted. Did that mean, the cartoonist Rube Goldberg asked, that if he called a pancake a two-thousand-dollar bill he could deposit it? Good or bad, the press coverage thrilled the sponsors of the upcoming art exhibition, who were masters of publicity.

In 1908 a group of artists, many of whom had worked as editorial cartoonists, had staged an attention-getting show of their own. Called The Eight, their exhibition at the Macbeth Galleries was a slap in the face of a sedate city. The painter Everett Shinn called it a challenge to "a deceitful age, drugged in the monotony of petty falsification." For the first time, American art lovers accustomed to paintings of pretty sunsets, soft pastel flowers, and elegant ladies were shown images of urban life in all of its beauty, tragedy, and sprawl.

Now, five years later, one of The Eight was spearheading an international effort with much more ambitious aims. Outside of a few radicals who had gone to Paris or ventured into Alfred Stieglitz's 291 gallery on Fifth Avenue, no one in America had seen the art that had evolved in Europe since the

impressionists of the 1880s. In 1912, Arthur B. Davies and his colleagues went to Europe to see and bring back the most challenging and experimental art that they could find.

Once the artists knew what they had, they used the very latest public relations techniques to bring the artwork to the attention of the city. They priced out renting an electric billboard on Times Square, commissioned a flag of rebellion, and did their best to spread rumors in the papers of what was coming. That was what they planned. But neither the agitated city nor the committee of conspiratorial artists was ready for what actually took place: the single most important art event in American history.

During the month that the show was open, eighty thousand artists and art critics, society matrons and college students, labor radicals and jeweled plutocrats flocked to the large, barn-shaped armory on Lexington Avenue between 26th and 27th Streets and had their eyes assaulted. Faced with the latest French art, the *Herald* critic found "faces that look as if their owners were dying of strangulation, bodies whose knees are longer than their torsos, soulful young women with their mouths stuck in the middle of their cheeks." The

Evening World thought the paintings looked as though "a poster for a Russian ballet, painted by an artist suffering from delirium tremens, had been rolled on before it was dry by a large, shaggy Newfoundland puppy." Royal Cortissoz, a leading art critic, thought the new paintings were designed "to make our flesh creep." The *Brooklyn Eagle* went even further, seeing in the exhibition "evidence of decadence, which is a sign of death." "American art," the *Evening Post* warned its readers, "will never be the same again."

Writing in the *Globe*, another critic realized why the new art was so terrifying. The viewer, he wrote, "will have to rearrange all his preconceived notions of what the world looks like, what humanity means." This was no easy task. For the first time New Yorkers were confronted with the strong colors and distorted lines of postimpressionists like Vincent van Gogh. They had to make sense of the even more extreme colors and blatant sensuality of painters like Henri Matisse. Matisse and his school were called fauvists, from the French for "wild beasts." Worst of all, the audience was confronted with cubists like Pablo Picasso who shattered faces into a tangle of colliding planes.

These cartoons made fun of the paintings and sculptures at the Armory, and showed how puzzling they were. But they also publicized the new art. The show asked: Where is the disorder, the madness? In our minds? In the art? Out in the world?

(The *Evening World*, February 22, 1913;
The *World*, February 17, 1913.)

For those who could appreciate the new art, the show was a revelation. This art perfectly fit a city of noise, cars, and skyscrapers. "When one leaves the exhibition," wrote the lawyer and art collector John Quinn, "one goes outside and sees the lights streaking up and down the tall buildings and watches their shadows and feels that the pictures . . . have some relation to the life and color and rhythm and movement" of New York.

All of the critics' anger and the new converts' passion centered on one great painting: Marcel Duchamp's *Nude Descending the Stairs.*

Nude, was that the problem? A naked woman on display in strait-laced New York? Not at all. Everyone knew what painters, especially those from Paris, liked to paint. The real crisis was just the opposite: Duchamp had promised a nude and no one could see it. Was he kidding? The *Press* saw "a

Marcel Duchamp's *Nude Descending the Stairs, No. 2,* **the painting that challenged American art and American eyes.**

(57⅞" x 35⅛". Courtesy of the Philadelphia Museum of Art: Louise and Walter Arensberg Collection and © 1998 Artists Rights Society, NY/ADAGP, Paris/Estate of Marcel Duchamp.)

bundle of fresh shingles heaped in a disorderly pile." Was the artist making us look stupid as we searched and searched for the body? Or was there something hidden amid those clattering rectangles that the *World* thought looked like "an elevated railroad stairway in ruins after an earthquake"? No one could be sure. So *American Art News* ran a contest. Readers were invited to find either the nude or the staircase. The ten-dollar prize was awarded to this novel entry, "It's only a man."

Nude split the public into three factions. To one group, it was a return to barbaric primitivism, or at best a joke. Ex-president Theodore Roosevelt made that view clear. "Take the picture which for some reason is called 'A naked man going down stairs.' There is in my bathroom a really good Navajo rug which, on any proper interpretation of cubist theory, is a far more satisfactory and decorative picture." Later critics would agree with him, only in reverse. Rather than condemning *Nude,* they praised Navajo rugs. One of the issues the new art raised was whose culture was more advanced, and what did progress in culture mean anyway? At the furthest edge of twentieth-century Western art, the most sophisticated artists were finding inspira-

tion in work by the very "primitive" peoples who were deemed inferior by most Western thinkers.

To people like Roosevelt—a large majority at the time—art was a kind of perfection. The artist not only reproduced the world around him, he raised it to a higher level. By conforming to well-established standards of beauty, the artist transformed the raucous jangle of daily life into refined images. The Christian ideals that guided a person in her relationships with other people, in her thoughts about God, and in her family life were expressed in another form by this kind of art. Daily life, moral rules, art that depicted life, and rules of art all lined up in a neat row. The new art violated all these norms. A title that did not match a painting was a kind of lie. "There is nothing," the *Evening Post* complained, "no beauty, no emotion, no passion, no sin; only different colored triangles."

Many of those who liked *Nude* reversed every term in this equation: The real world looked nothing like old-fashioned paintings. People's lives were filled with hypocrisy and lies. Art had no obligation to resemble anything, and it could be judged only by its own new rules—which were being reinvented daily. To these radicals *Nude* was exciting

Brooklyn Society

After the shock of the new art, cartoonists began to use it to interpret the city. Futurist art (this cartoon is actually closer to expressionism) was not crazy; it made it easier to capture the feeling of a rush hour crowd. While the people, dogs, and horses of the city had to be caricatured to resemble the controversial paintings, the elevated trains, cars, and skyscrapers already were futurist creations. In reverse, the giant billboard asks, "The New Art, Are We Heading This Way?" Perhaps the cartoonist sensed the answer: yes.

(Brooklyn *Daily Eagle*, February 20, 1913; The *Herald*, February 18, 1913.)

NEW YORK STREET AS THE "FUTURISTS" SEE IT.

Extreme Art Draws Crowd at Opening

precisely because you could not see the figure. If Duchamp's title made fun of the viewer, so much the better for being such a good joke. If the whole city was scratching its head and feeling foolish, what a triumph! If people knew anything about their false and meaningless lives they would feel that way all the time. A liberal professor named Joel Spingarn, who was one of the founders of the NAACP, explained that "the virtue of an industrialized society is that it is always more or less sane. The virtue of all art is that it is always more or less mad."

Duchamp himself said the painting was "the convergence in my mind of various interests, among which are the cinema still in its infancy, and the separation of static positions in photochronographs." That is, he had been watching movies and studying stop-motion photographs. The world looked different once you had seen it on camera or in a film. It sounded different once you had listened to a phonograph or, later, a radio. And that led to still a third view, one that reversed the equation of art and life yet again.

What if life itself had changed? What if cars, telephones, x-rays, and skyscrapers had transformed the world? Maybe an art that accurately reflected the times had to be as fast-paced and unpredictable as the city streets. If Duchamp painted a nude as seen by a stop-motion camera he wasn't making fun of people, he was educating their eyes. He wasn't being radical, satirical, subjective, or primitive, he was merely creating a new kind of realism. The writer Julian Street understood that. Duchamp, he wrote, "attempts to place on canvas the impressions of life which pass across the mind as kinemacolor [movie] pictures pass across the screen."

Nude was not just a picture, it was a catalyst exposing the splits in the public. Standing in front of it, moralists argued with radicals while critics offered explanations and scoffers literally stood on their heads. A writer for the *Independent* imagined that if there were a camera inside a picture filming the crowd it would show "awe, scorn, disgust, amazement, pleasure, amusement, puzzlement and adoration." How perfect. The confusion in the crowd exactly matched the chaos in the art. An avant-garde painting revealed what people felt but could not yet express. Yet interest in the painting was not limited to art lovers, and this threw the radicals a very difficult curve.

In the wake of the Armory Show the American avant-garde began to take shape, but not all of it was in America. Believing they had to imitate the French in order to become original, many young painters steamed off to Paris to learn the new styles. Department stores saw the advertising potential in this. Wanamakers staged a kind of fashion show in which women tried to look like the new paintings. According to the *Evening Sun,* on the sides of the stage were "two huge canvases wherein the women have the conventional orange hair and green cheeks." The Gimbels department store chain sent an agent to Paris to buy one hundred dollars worth of cubist paintings, which were then exhibited in Milwaukee, Cleveland, Pittsburgh, New York, and Philadelphia. According to the company, they hoped "to capitalize on the Armory Show's notoriety and to gain favorable publicity for the store." The very art that seemed so revolutionary was immediately used to pull shoppers into stores.

Cartoonists, advertisers, and newspaper editors soon began their own experiments with the new art styles. Both the *Tribune* and the *World* hired Picabia to draw familiar sights around town so that their readers could see what a cubist made of the world they knew. The *Evening Sun* ran an irregular series of cartoons entitled "Seeing New York With a Cubist," which included topics such as traffic jams, opera crowds, and "The Rude Descending a Staircase (Rush Hour at the Subway)." As John Quinn had sensed, the art and city suited each other. James Daugherty, a painter from North Carolina, found another way to apply the new French theories. His *Futurist Picture of the Opening Game* was printed in full color in the April 12, 1914, issue of the *Herald*. If art that was supposed to threaten the foundations of civilization could be used to describe the national pastime, how scary could it be?

Village Nation

Early jazz, such as the recordings of Louis Armstrong's Hot Five and Hot Seven groups, fits here. Warren Beatty's excellent 1981 film **Reds** *is perfect for this section.*

When the avant-garde extended beyond art, it was not so easy to tame. The hope of being part of this exciting newness, whatever it was, drew many bright, talented, and articulate young people to Greenwich Village in New York City. Starting in the 1910s, they gathered in tearooms, studios, and bookstores. There they talked, painted, planned strikes, fell in love, argued, and generally thumbed their noses at the rest of society. For the Village radicals, the challenge of the Armory Show went far beyond painting. At the Ferrar School in East Harlem, they taught everything from anarchism and socialism to birth control, free love, and the international language Esperanto. "Nearly every thinking person nowa-days," Mabel Dodge Luhan announced proudly, "is in revolt against something."

If there was one person who seemed to prove that the conservatives were right to link the new art with radical ideas it was Mabel Dodge Luhan. Wealthy, well-connected, and an accomplished hostess, she held a salon in her Village apartment on Fifth Avenue and Ninth Street that was open to every kind of revolutionary. This is how she remembered those fevered parties:

> Imagine, then, a stream of human beings passing in and out of those rooms; one stream where many currents mingled together for a little while.
>
> Socialists, Trade-Unionists, Anarchists, Suffragists, Poets, Relations, Lawyers, Murderers, "Old Friends," Psychoanalysts, I.W.W.'s [labor radicals], Single-Taxers, Birth Controlists, Newspapermen, Artists, Modern-Artists, Clubwomen, Woman's-Place-is-in-the-home women, Clergymen, and just plain men all met there.

The Villagers who came to Luhan's parties were full of hope. The novelist Floyd Dell explained why: "We have seen changes in machinery, and changes in institutions, and changes in men's minds—and we know that nothing is impossible." Established

art styles, moral rules, and systems of government seemed equally useless, and changeable. John Reed, who would go on to write a famous history of the Russian Revolution, worked on the *Masses,* a magazine that was determined "to everlastingly attack old systems, old morals, old prejudices—the whole weight of outworn thought that dead men have saddled on us." This contrast of old and new was on all of the Villagers' minds.

Randolph Bourne had overcome disfigurement and a childhood disease that left him hunchbacked to become a popular and lively student at Columbia University. He wrote that "it is the glory of the present age that in it one can be young. Our times give no check to the radical tendencies of youth." "Instead of a world once and for all fixed," argued the brilliant critic Walter Lippmann, "we have a world bursting with new ideas, new plans, and new hopes. The world was never so young as it is today, so impatient of old and crusty things." The Village avant-garde were rebels in favor of the new over the traditional, the young over the old, the experimental over the known. They went at it with a vengeance.

On a cool January night in 1917, six Villagers, including Duchamp himself and John Sloan—one of The Eight and a confirmed socialist—climbed the arch that still stands at the entrance of Washington Square Park. In the flickering candlelight they drew up a document "to establish the secession of Greenwich Village from the United States." They didn't have to bother, everyone already knew that the Village was a place unlike any other.

When they weren't planning strikes, writing or painting about class struggle, experimenting with every kind of love affair, or drinking, the Villagers were searching everywhere for a new kind of America. Following Bourne, many of them argued for a "cosmopolitan" nation open to many different races, cultures, and ideas.

The Villagers' radical ideas showed that conservatives like Roosevelt had been right. If you enjoyed the new art, you were likely to look on the nation's minorities in a new way. If you thought of America as a white, Christian nation with an essentially European culture, new art that looked "primitive" was a step backward. It was a sign of decadence. But if you thought that the vital, exciting part of America could be found on Indian reservations, in immigrant ghettos, in the music and stories of

John Sloan titled this etching showing the Villagers in the act of declaring independence *Arch Conspirators.* This is a pun on the Washington Square Arch, where they were having their party, and the idea that they were extreme radicals. (4½" x 6". Courtesy Kraushaar Galleries, New York.)

African Americans, then there was nothing more modern than rejecting traditional art. The argument about the art in the Armory Show, then, was not just about art, or even morals, but about the very kind of country America was to be. What was the future of the nation—the Village or the small town?

Those debates should sound familiar, they have continued to this day. But now, the wildest art of the Armory Show can be found on the walls of the most conservative museums. *Nude* no longer shocks anyone. How is it that artistic taste can change so much while the surrounding conflicts remain? To understand how radical art and radical ideas fit together, we have to switch our attention to Paris, the city that gave birth to the avant-garde. For, very shortly after the Armory Show moved on from New York to Chicago, the most important artistic explosion of our time took place in France.

Nijinsky Against the World

Igor Stravinsky's **Rite of Spring** *fits best at the end of Chapter 4, but you can sample it here to get a taste of what is coming. The most controversial part of the score, appropriately enough, is a section called "the dances of the adolescents." Listen for the driving, propulsive rhythms.*

Paris, May 29, 1913

The premiere of the ballet *Rite of Spring* was the defining moment of the avant-garde. The piece was choreographed by Vaslav Nijinsky, perhaps the greatest male dancer ever. Nijinsky jumped impossibly high and hovered in the air inhumanly long, which was only the smallest part of his gift. On-stage he did not act, he became the part he performed. Think of the most compelling and erotic male performer you can imagine, then raise him to a higher power. That was Nijinsky's effect.

When the troupe of Russian artists, musicians, and dancers called the Ballets Russes staged ballets about harem slaves or pagan demigods Nijinsky transfixed the audience. To Parisians he seemed the essence of barbaric Slavic passion mixed with perfect classical training. His love affair with Sergei Diaghilev, the company's leader and producer, added a dangerous sexual ambiguity to his aura. When Nijinsky married, Diaghilev rejected him and the dancer went mad. That only seemed to prove the lack of boundaries in his life, and his total commitment to art. When Nijinsky choreographed his own ballets, he went beyond the pleasantly erotic into the sacred unknown.

The opening night of *Rite of Spring* was two simultaneous events in one. On-stage and in the orchestra a new kind of art was taking place. In the audience, a riot broke out. What exactly took place in the aisles is open to dispute. We are sure of insults and perhaps fistfights. Outraged listeners tried to drown out the music while avid fans applauded it enthusiastically. Whether duels were actually fought over it, or if the Comtesse de Pourtalès really stormed out saying, "I am sixty years old and this is the first time anyone has dared to make fun of me," remains uncertain. But the shock waves around the piece are still being felt today.

The first performance of *Rite,* including the clash over it, appears in countless histories. Anyone who wants to show what happens when new art challenges old beliefs is sure to mention it. If the Armory Show rewrote the rules for American art, *Rite* set a new standard for the avant-garde in the entire world. The homage to spring and rebirth on the stage of the Théâtre des Champs-Élysées announced the arrival of the modern age. To understand why *Rite* was so shocking and so powerful we have to step back a moment to see how art, politics, scandal, and publicity came together in Paris.

Protest in Paris is different from agitation in any American city. Washington D.C. was created to be the nation's capital. New York has long been America's financial and artistic center, and Boston was regarded as the intellectual leader from colonial times to the 1890s. Philadelphia, Baltimore, Charleston—and later on Chicago, San Francisco, Los Angeles, Dallas, and Atlanta—have become important power bases of their own. A scandal in Boston, a union rally in New York, a disputed election in Chicago might go totally unnoticed in Washington. Moreover, in America, each state government has great power within its own borders. But in France, Paris is not only the single financial, artistic, and governmental center, it is the hub from which the whole nation is run. "In France," wrote the eighteenth-century philosopher Montesquieu, "there is only Paris and a few provinces Paris hasn't found time to gobble up." When the people of Paris get angry, they have a real chance of reshaping the nation.

The special role of Paris was crucial to the history of the avant-garde. The cheap rents and intense interest in the arts in Paris allowed many poor and experimental artists to live and work

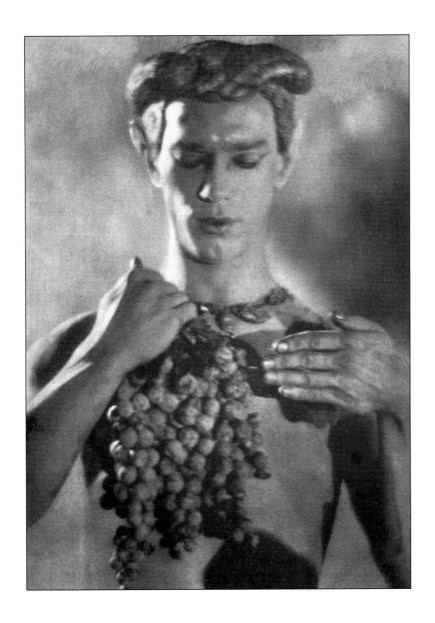

there and to find others of similar temperament. You can still visit many of the Parisian cafés and bars where these radicals met. Because the artists were in Paris, their unorthodox lifestyles and extreme views posed a constant threat to the national government. It is as if the president, every governor, and all of Congress ran the nation from a TV studio where they had to answer nightly questions from rap singers, protesters, standup comics, and angry poets.

Nijinsky as the pagan faun in
Afternoon of a Faun.
(Photo used with permission and is copyright Eakins Press Foundation.)

Breaking the Rules: Bohemianism

A good musical accompaniment to this section is Hector Berlioz's Symphonie fantastique, *which premiered in 1830. It tells the musical story of an artist's life, including an opium dream and a witch's sabbath. It was as popular, and as controversial, as the most extreme music of our time.*

Paris, 1830

Paris's combustible mix was first set off in 1830. The first performance of Victor Hugo's play *Hernani* provoked a scandal that was a direct forerunner of the opening night of Nijinsky's *Rite*. For centuries, French drama had followed very strict rules of form and language. Hugo decided to reject them totally. This was no quiet literary controversy. Four hundred of the playwright's long-haired supporters, dressed in wild colors and armed with clubs, fought with outraged traditionalists. This clash had much wider implications. The radicals who opposed old artistic rules paralleled a growing dissatisfaction with the French monarchy. That July, the king was overthrown. Extreme art predicted political revolution.

In the 1830s and '40s, more and more young people flocked to Paris, hoping to make a living and to rise beyond their parents' status. Though there were many traditional avenues for this advance—much like the career tracks that take people through high school, college, and professional training today—a special variant started to take shape in Paris. Styling themselves after the artistic radicals, some young people began to con-

sider themselves *bohemians*—French slang for gypsies. Some were best known for their eccentricity. The poet Gérard de Nerval took his pet lobster out for walks, explaining that "it does not bark and knows the secrets of the deep." Others dressed in medieval clothing, claimed they drank out of skulls, and sported every variety of long hair.

The bohemian life soon came to mean more than being unusual. Bohemians were notorious for drinking and taking drugs. Some held radical political views that ranged from socialism and anarchism to a disbelief in any kind of shared reality. Most were thought to have unconventional or experimental personal relationships. Becoming a bohemian meant rejecting society, rejecting the very career ladder young people came to Paris to pursue. And yet this was only partially true. Bohemians lived cheaply, staying in poor parts of town, scrounging a livelihood from marginal and sometimes illegal activities. Some students became bohemians only until they could afford to do better. And others found that writing about their eccentric friends could bring its own kind of fame and, if not fortune, at least small income.

Henry Murger was one of the first bohemians to write about bohemia. When he arrived in Paris, newspapers and magazines were cropping up daily. If they did not last long, they gave a young writer a place to start. Murger's most famous book began just that way, as a series of articles in a short-lived newspaper. In 1851 his *Scenes of Bohemian Life* was published as a book. It defined bohemia forever: the starving artists living in garrets, the loyal young women who believed in them, the mix of dishonesty and passionate love in their lives. It also identified the most important characteristic of being a bohemian. When Murger's frail heroine Mimi dies, her lover Rodolphe sobs, "my youth is dead." As we saw with the Village radicals, to be bohemian means to be young. But what is that? What does being "young" mean?

Just as the bohemians began to gather in Paris, people were rethinking the stages of life. For the first time, they identified a phase between being a child and an adult. Young adulthood was an invention that was as much a product of its time as were railroads, factories, or photographs. As fewer and fewer people worked on farms, or remained in their parents' villages, they needed a time of life in which they left home and figured out who they

were going to be. In one sense this was a matter of gaining new skills—training to be a lawyer, or an accountant, or a teacher. But in another it meant agonizing about their identities. Did they accept traditional values or reject them? Did they want to return to old rural ways or embrace modern urban life? If past ways were dead, what would come next—a utopia or a nightmare? Was anything stable in a changing world?

These practical and psychological choices were at the heart of bohemianism. Typically bohemians proclaimed wild ideas and were angry at the world. They made do on little money and were uncertain about their future. They wanted to shock established society, but they also craved recognition. They were contemptuous of rules but obsessed with cliques and factions. This should sound very much like teenagers or college students. To be bohemian is to be young. The more people who are going through this time of life, the more chance of a bohemian movement.

Murger's book was based on his own circle of young friends, who called themselves the Water-Drinkers and gathered at the Café Momus. Few achieved any artistic success, and they made money any way they could. Murger, for example, earned a steady income as a kind of political spy for a Russian count. There was another French revolution in 1848, and the Momus circle included utopians, visionaries, and radicals. This meant that Murger had valuable information to pass along. Even if readers did not know about his spying, many saw him and his characters as the essence of shiftless, amoral, radical bohemia. In time, though, even that gave him a kind of honor.

By 1895, Parisians looked back at Murger so fondly that a bust was erected in his honor. The following year, the Italian composer Giacomo Puccini presented an opera based on Murger's work. Today, *La Bohème* is the most popular opera in the world. Most recently it inspired the Pulitzer Prize–winning musical *Rent*. From the first, then, being a bohemian meant having disturbing ideas and selling that image of yourself—living on the edge and making sure others knew that you were. This doubleness did not make bohemian art any less dangerous or powerful.

The Flowers of Evil

The sound of "L'invitation au voyage" is as important as its meaning. You can hear it in Henri Duparc's song of the same name. A composer from this era whose work still sounds quite experimental and weird is Charles Valentin Alkan—a truly strange man who produced truly strange music. His **Le festin d'Esope (Aesop's Feast)** *is a musical rendition of a meal that, from appetizers to dessert, consisted of tongue.*

The most famous bohemian of this period was the poet and critic Charles Baudelaire. Baudelaire knew Murger, as well as many of the other Momus regulars. An admirer and translator of Edgar Allan Poe, Baudelaire not only appreciated the American's writing, he embraced the excesses of Poe's life. Baudelaire set out to drink, use drugs, and blend in with the surging street crowds. All for a purpose. In the same quest he explored and cele-brated unconventional sexuality, wasted himself, even painted his hair green. Baudelaire's goal was the total "vaporization of the self." Having done his best to shatter himself, he then devoted himself to "concentration," to setting down his discoveries in poetic form. Even as he described the most extreme experiences, he wrote highly crafted, for-mal poetry. The title of his most important poetry collection captures that duality: *The Flowers of Evil*.

The following poem is typical of Baudelaire. By now it may seem entirely tame, a classic that could appear in any high school French textbook. Yet its balance of sensual, almost narcotic languor with precise, elegant words and rhythms is a startling accomplishment. It shows art as an alternative to familiar life that is, at the same time, a jewel, a per-fection, of that life.

L'invitation au voyage
(Invitation to the Voyage)

My child, my sister, dream
How sweet all things would seem
Were we in that kind land to live together,
And there love slow and long,

There love and die among
Those scenes that image you, that sumptuous weather.
 Drowned suns that glimmer there
 Through cloud-disheveled air
Move me with such mystery as appears
 Within those other skies
 Of your treacherous eyes
When I behold them shining through their tears.

There, there is nothing else but grace and measure,
Richness, quietness, and pleasure.

 Furniture that wears
 The lustre of the years
Softly would glow within our glowing chamber,
 Flowers of the rarest bloom
 Proffering their perfume
Mixed with vague fragrances of amber;
 Gold ceilings would there be,
 Mirrors deep as the sea,
The walls all in an Eastern splendor hung—
 Nothing but should address
 The soul's loneliness,
Speaking her sweet and secret native tongue.

There, there is nothing else but grace and measure,
Richness, quietness, and pleasure.

 See, sheltered from the swells
 There in the still canals
Those drowsy ships that dream of sailing forth;
 It is to satisfy
 Your least desire, they ply
Hither through all the waters of the earth.
 The sun at close of day
 Clothes the fields of hay,
Then the canals, at last the town entire
 In hyacinth and gold:
 Slowly the land is rolled
Sleepward under a sea of gentle fire.

There, there is nothing else but grace and measure,
Richness, quietness, and pleasure.

From the first line, Baudelaire is taking us on a strange voyage. Is he addressing a child, or is he addressing a lover—who could even be a sister—as a child? Perhaps he himself is being ensnared by a vision he sees in her tear-filled "treacherous eyes." And where is he inviting her to go? In one sense to a place of luxury and sensuality. In this land all pains will be soothed with "richness, quietness, and pleasure." But this is a writer who well knows "the soul's loneliness." He feels how isolated we are, all

of us. There is nothing sloppy or sentimental about Baudelaire.

The poem, you might say, is the journey. Its hypnotic words transport us into a world in which there is only beauty. But the poem is only an invitation, which implies that the voyage has not been, perhaps cannot be, undertaken. Baudelaire completely gives himself to the world he creates, daring to feel the most forbidden feelings. Yet he stands apart from it, viewing it as a separate creation, a work of art.

Baudelaire is moving in two opposite directions: he is going toward a sea of feeling and luxury in which we drown ourselves in dreams. And yet he is writing a perfect poem in which all is "grace and measure." There is not an extra word, or even syllable, in the poem. Baudelaire recognized that modern life isolates all of us, which makes us all the more preoccupied with our hidden and dangerous yearnings. But he saw that the artist of modern times would have to make art that was as sharp and defined as science.

Baudelaire's poem is filled with visual imagery, and it pointed to some of the other artistic conflicts of his day. "Eastern splendor" was a popular subject for French painters. They often depicted lavish scenes set in North Africa—complete with harems and seminude women—that featured exotic fabrics and settings drenched in rich colors. This kind of art was not considered particularly experimental or challenging. The artists who drank at the cafés with Baudelaire had other interests.

Respected painters who did not depict slave girls focused on grand subjects with religious, national, or mythical themes or made portraits of wealthy patrons. The radicals did none of that. A half century before The Eight, they began to explore the ordinary world around them. Some of them had explicitly socialist sympathies. To paint a laborer or farmer, not a prince or hero, was to make a political choice. Others sensed that city life had shifted all of the old rules. Now everyone was an isolated observer like Baudelaire or part of a crowd. Their paintings reflected this alienation or depicted the new diversions of Parisian life.

Gustave Courbet drank with the Momus regulars in the 1840s. A socialist who strongly identified with country folk, Courbet set out to paint realistic paintings. By showing life exactly as it was, with no painterly prettiness, he was trying to create a

Vincenzo Marinelli's 1862 *Song in the Harem* is typical of paintings that displayed exotic lands and semierotic scenes. (Dimensions unavailable. Courtesy Alinari/Art Resource, NY.)

new kind of society. "Realism," he proclaimed, "is democracy in art." As we saw with Saint-Simon, the term *avant-garde* was originally coined to describe exactly this link of political and artistic challenge. Yet, Courbet and his realistic socialism in paint did not remain in the vanguard for long. Though he was explicitly standing up to society, his talent combined with his politics made him all the more famous. And soon artists were moving on to quite different challenges.

As they began to treat new subjects, painters were also starting to examine what painting itself meant. Should a painter try to create a window into an imaginary world, using techniques to fool

the eye perfected over hundreds of years, or was that entire effort rendered useless by the camera? If a camera could be more realistic than any brush, why bother aiming at that kind of realism? Perhaps painting was not about the world the painter saw or imagined but rather about the act of seeing and painting? Could the shifting light and the strokes on the canvas be the subject of painting, not merely its method? Just as Baudelaire wanted to vaporize himself to find a new art, some painters were giving up the aim of painting pictures that looked real in order to explore new artistic realities.

Gustave Courbet's 1854–55 painting, *Interior of My Studio, a Real Allegory Summing Up Seven Years of My Life as an Artist,* **told many stories at the same time. While the artist paints an outdoor scene that he cannot see, he ignores real life and all the potential models that surround him.** (11'10" x 19'7". Courtesy Giraudon/Art Resource, NY.)

Two Strange Picnics

Impressionism in art was paralleled by a musical movement with the same name. Pieces like Claude Debussy's Images *and Maurice Ravel's* Miroirs *date from a slightly later period. But they perfectly capture the play of light and surface, like sunlight on water, in impressionist painting.*

Edouard Manet and Claude Monet are easy to confuse because of the similarity of their names, but their works have little in common. Instead, they illustrate the distinct new directions painters took in the second half of the nineteenth century. In the late 1860s, Manet was a regular customer at the Café Guerbois, where he met with other painters such as Edgar Degas, Paul Cézanne, Auguste Renoir, and Monet to debate about art and life. Both he and Degas painted people drinking absinthe—a liqueur made from wormwood that was popular, potent, and toxic. Absinthe is now illegal in most countries, including France. A friend of

Baudelaire's who read his translation of Poe, Manet made his own explorations of the outer limits of art.

The special place of Paris in France, and of art in Paris, played its part in making Manet notorious. From 1737 on, a select jury of the French Academy chose work to appear in an annual art exhibition that came to be called the Salon. Since there were no private art galleries, and no competing exhibitions, this was the only way to have a public showing in Paris. If your work was picked for the Salon, you had a good chance of becoming a successful artist. If it was not, you had to try another career— or make do as a bohemian. Art was important to the French, and had a thriving market, but only if it was picked for the Salon.

As French artists began to paint in new ways that were sure to be rejected by the Academy, they realized that they would have to exhibit on their own. This was a big step. They gained exposure and risked total failure. The first alternative exhibition, the Salon des Refusés, premiered in 1863. It is indicative of the role of culture in France that even this controversial exhibition was supported by the government of Napoleon III.

Some of Manet's paintings seemed designed to

provoke and make fun of the very people who were expected to judge and buy them. His *Luncheon on the Grass* was the shocking centerpiece of that first Salon des Refusés. The painting shows a conventional countryside with four very unconventional people. The two men are overdressed for a picnic and one of them seems to be staring blankly at the viewer, while one of the women is—inexplicably—undressed. Nothing about the scene makes sense. It was as if Manet started an old-fashioned work and then suddenly added a totally different one that simultaneously made fun of the first and showed what the men were really thinking about. Not only did the mismatched men and women hint at sexual secrets beneath the surface of an elegant picnic, Manet's technical skill and weird humor made it impossible to take any traditional painting seriously. Even today, the jarring juxtaposition of the characters looks more like the kind of mixing done on computer screens than a formal painting.

Two years later, Manet found a way to be even more controversial. In any ranking of

One reason why Manet's *Luncheon on the Grass* remains as enigmatic today as when it was painted is that it is hard to tell where we stand in relationship to the scene. The undressed woman seems to see us, but the man next to her stares ahead blankly, while the second man is so caught up in making his point that he doesn't notice either the woman's nakedness or our presence. The second woman may be coyly displaying herself or not a part of the foreground scene at all.

(7' x 8'10". Courtesy Giraudon/Art Resource, NY.)

the great art explosions of our time, the scandal over *Olympia* belongs in the top row, next to the openings of *Hernani* and *Rite of Spring.* Paintings of nude women were a staple of French art. Those exotic North African scenes and voluptuous goddesses came very close to what we would now consider soft porn. Many men thought of an art exhibit, or a dance performance, the way we view an adult magazine or an R-rated movie. *Olympia* broke the rules of acceptable nudity. The painting was not more sensual or explicit than others. If anything, it was just the opposite.

The woman in the painting was so matter-of-fact, staring directly back at the viewer, that she might as well have been a prostitute. Manet made no effort to make her, or the scene, pretty. The lush sheets, covers, and curtains only made her look all the more like an item on display. She was for sale, and to men she did not have to pretend to like. The flowers, perhaps a lover's gift, were not even fully painted. The black maid and black cat may have hinted at the forbidden or magical or suggested a parallel between two kinds of servitude.

It was this directness, bordering on ugliness, that was so disturbing to reviewers. One called *Olympia* "a sort of female gorilla, a grotesque in India rubber outlined in black." Another said "her body has the livid tint of a cadaver displayed in the morgue; her outlines are drawn in charcoal and her greenish, bloodshot eyes appear to be provoking the public." A particularly perceptive reviewer, Jean Ravenel, summed up all the issues around the painting:

> The scapegoat of the salon, the victim of Parisian Lynch law. Each passer-by takes a stone and throws it at her face. *Olympia* is a very crazy piece of Spanish madness, which is a thousand times better than the platitude and inertia of so many canvases on show in the exhibition.... Painting of the school of Baudelaire ... from the mysteries of Paris and the nightmares of Edgar Poe. Her look has the sourness of someone prematurely aged, her face the disturbing perfume of a flower of evil; her body fatigued, corrupted, but painted under a single, transparent light, with the shadows light and fine.

Olympia was Baudelaire in paint. It stripped life of all its covers, exposed its sickness, and made unsparing truth into a new kind of art. Just as *Nude Descending the Stairs* upset New Yorkers by not being

The matter-of-factness of Manet's *Olympia* is the total opposite of Marinelli's harem scene. Only the pillows are soft and sensual. The naked body is an item for sale, not a source of fantasy. (51⅜" x 74¾". Courtesy Giraudon/Art Resource, NY.)

a recognizable nude, *Olympia* disturbed Parisians by being naked.

While the controversy over *Olympia* raged, Claude Monet was painting a picture with the exact same title as Manet's challenge of two years earlier: *Luncheon on the Grass.* Monet's was entirely conventional, filled with recognizable and fully clothed figures enjoying the afternoon light. And yet, it pointed to another artistic rebellion, and this one would ultimately prove to be the most enduring and most complete of all. Monet and the other impressionist painters started to take apart painting entirely. Instead of working with controlled light in a studio, so they could create paintings that looked

This detail from Monet's _Luncheon on the Grass_ most closely parallels Manet's shocking painting. The dappling of light in the leaves, where distinct shapes blur into patterns of color, hints at the impressionism that became Monet's signature style.

(48⅞" x 71¼". Courtesy Foto Marburg/Art Resource, NY.)

just like nature, they painted out in the air, seeking only to capture the flickering patterns of light. If art was going to mirror life as we actually experience it, it could no longer look lifelike. On the frontiers of the Parisian avant-garde, the recognizable world was falling apart.

The postimpressionists, fauvists, and especially the cubists who so disturbed the New Yorkers at the Armory Show merely took the next logical steps after the impressionist revolution. If a painter did not have to paint "realistically," he could exaggerate or distort any shape to convey a psychological truth. If colors did not have to be chosen to mimic nature, they could tell their own emotional stories. If a painter was setting his own rules for his canvas, why couldn't he show a person or object from many different angles at once? Duchamp used a camera to capture all of the nude's steps in one painting. In the first years of the twentieth century, painters like Pablo Picasso and Georges Braque went further, abandoning any link to the familiar world. In their canvases everything was reduced to a set of rectangles, cubes, and intersecting lines. It was as if their eyes had turned into prisms. But then, everything else in life seemed just as fragmented.

"The Disorder of My Mind"

For music that echoes the themes of this section we have to make some leaps. The operas of Richard Wagner can be interminable, but they are appropriate. If you are receptive to them they offer music of unique power and beauty. The music of 1960s artists such as Bob Dylan, the Velvet Underground, and the Doors is equally apt and more accessible.

Paris, 1871

In 1871, Paris experienced yet another political revolution, and this was the most extreme, bloody, and radical of all. The previous year the French had fought and lost a war with the Prussians. During the conflict, Paris suffered a four-month siege that drove many to the brink of starvation. Wealthy people dined on elephants and bears from the zoo, while the poorest made do with rats. The victorious Prussians seized two French regions, Alsace and Lorraine, and insisted on staging a triumphal march through the streets of Paris. Though the Parisians abandoned the center of town, leaving the occupiers to parade alone, they felt humiliated and betrayed. This was made worse by the nature of the new French government, which was conservative and reflected the beliefs of the provinces, not the capital.

From the heady years of the first French revolution in the 1790s, generations of vocal Parisians had argued that the country should be run on socialist or communist principles. They viewed every government since those radical times as a miserable

compromise and were willing, even eager, to stand against the rest of the nation for their ideals. As we have seen, these political extremists were often part of the bohemian mix. Some artists shared their views, while others felt sympathetic to their disgust with middle-class life. The combination of the terrible defeat by the Prussians and the despicable new government gave these militants their great chance.

On March 26, 1871, the people of Paris voted to create a new government of their own. The Paris Commune, as it was called, was the high-water mark of French radicalism. "What is happening," noted the brothers Edmund and Jules de Goncourt in their journal, "is nothing less than the conquest of France by the worker." By May, though, the national government assaulted and overwhelmed the city. Over twenty thousand Parisians were killed, and another thirteen thousand were tried, convicted, and sentenced to live in miserable prison colonies overseas.

The rise and fall of the Commune changed the rules of French life. On the one hand, many of the communards and their allies were dead, exiled, or imprisoned. The next outbreak of Parisian revolt did not take place for nearly one hundred years. On the other hand, the rest of France began to change. Rural areas, where people lived by ancient ways and often did not even speak French, were flooded with teachers who taught the virtues of reason, science, and progress. But this solved nothing for artists. As their work lost some of its political edge, its claims became all the more extreme. Now, instead of painting peasants to create a new democracy, some artists turned their backs on all of normal life.

This period marks the break between bohemianism and the avant-garde. The two are quite similar, but not identical. Bohemians often dressed strangely, pursued wild love affairs, and held extreme political views. All of these activities surrounded their art and contributed to their reputations. But their art could be traditional, and their lives often ended up being quite bourgeois. In addition, some people who lived bohemian lives never even claimed to be artists. For the avant-garde this changed. For them, being shocking, standing against society, living for the new and against the old, *was* their art. Bohemianism may be a stage or an affectation. Avant-gardism is a commitment.

The artist who most clearly made this break

was a poet, not a painter. The biography of Arthur Rimbaud reads like a modern Young Adult novel. During the 1960s many hippies used him as a model. Perhaps without knowing it, their descendants, today's slackers and stoners, are just as loyal to his legend. As a teenager Rimbaud was a talented poet who hated the small town in which he lived. "I am dying," he wrote at the age of sixteen, "I am decomposing in the dullness, in the nastiness, in the grayness." He kept running off to Paris, or to join a favorite teacher. This was not merely an effort to escape. He saw himself as a *voyant,* a poet with a special kind of mission. "The poet makes himself a *voyant* through a long, immense and reasoned *deranging* of *all his senses.* All forms of love, of suffering, of madness, he tries to find himself, he exhausts in himself all the poisons, to keep only their quintessences." These were not empty words; Rimbaud set out to live up to them.

Not yet seventeen, he wrote to an accomplished bohemian poet named Paul Verlaine asking for his help. Verlaine, who was married, encouraged him to join him in Paris and the two soon became lovers. Their intense, turbulent, finally violent attachment lasted for two years. Verlaine felt

Verlaine's drawing of the young Rimbaud in Paris.

that their homosexual relationship freed them, "because once the boundary is crossed, there is no longer any limit." They "dined on public condemnation and ate the same for supper." It was during this period that Rimbaud wrote his best poetry, including *A Season in Hell*. At the age of 20, though, he gave up poetry entirely and set out for Africa. There, he made a living as businessman and trader, even selling guns to kings who were involved in the slave trade. Never fully comfortable in either Africa or Europe, he died at the age of 37.

Baudelaire had also tried "deranging . . . all his senses," but Rimbaud felt he made a fatal error. The older poet explored drugs and sexuality in order to find material for his art, which was highly crafted and quite formal. Rimbaud envisioned a much more extreme link between derangement and the artist. Instead of using his mental voyages to create sacred art, Rimbaud considered "the disorder of my mind sacred." There was no difference between art and life. "If what he brings back from over-there has form, he gives form; if it is formless, he gives formlessness." The bohemian rejection of middle-class morals now turned into the avant-garde embrace of insanity.

Paradoxically, Rimbaud's rejection of artistic form would not much matter were it not for his artistic talent. Anyone can celebrate his nightmares, but Rimbaud made his into poetry that is still terrifying and brilliant. *A Season in Hell* is divided into sections, two of which are called "Deliriums." In the first he quotes an invented character, based on Verlaine: "At present, I am at the bottom of the world! . . . Never deliriums or tortures like these. . . . How senseless it is."

He continues with a passage that could describe today's city streets: "I will make gashes over my entire body, I will tattoo myself, I wish to become as hideous as a Mongol: you will see, I will howl in the streets. I wish to become quite mad with rage."

The section ends with an evocation of his love affair that seems both mad and innocent. These are extracts taken from two different paragraphs:

> I regarded us as two good children, free to roam within the Paradise of sadness. We suited one another.
>
> We shall travel, we shall hunt in wilderness, we shall sleep on the pavements of unknown towns, without cares, without troubles. Or I shall wake up, and laws and morals will have changed—thanks to his magic power. . . .

If only he were less wild, we should be saved! But his sweetness is also deadly. I am submissive to him. —Ah! I am insane.

In the second section of "Deliriums" he wrote what amounts to a forecast of the art and life of the twentieth century:

> I loved absurd paintings, panel-friezes, stage-settings, clowns' backdrops, signboards, popular colored prints; old-fashioned literature, church Latin, erotic books without proper spelling, novels of our grandmothers' time, fairy tales, little books for children, old operas, silly refrains, artless rhythms.
>
> I dreamt of crusades, voyages of discoveries of which there are no reports, republics without recorded histories, suppressed religious wars, revolutions in morals, movements of races and of continents: I believed in all enchantments.
>
> I invented the color of vowels! —*A* black, *E* white, *I* red, *O* blue, *U* green. I established rules for the form and movement of each consonant, and, with instinctive rhythms, I flattered myself on devising a poetic language accessible, one day or another, to all the senses. I withheld the translation.
>
> . . . I wrote down silences, nights, I recorded the inexpressible. I determined vertigoes.

Rimbaud's catalog of imagined art looks directly ahead to the major avant-garde movements discussed in the next four chapters. His desire to create a language "accessible . . . to all the senses," though, is even more prophetic.

Modern life is complicated, and modern people often feel isolated and alone. Ever since humans moved out of small tribes in which art was part of religion, religion was part of work, and nature was filled with spirits, we have sought to find ways to reunify our lives. One reason why avant-garde artists have been so interested in "primitive" art is that in such works they saw the kind of link of self, world, and god that was increasingly absent from industrial societies. But if avant-garde artists looked back to an ancient art that was totally infused with religious faith, they also made a religion out of their own art. Art that totally absorbs the audience holds out the promise of becoming the new Mass, the sacred ceremony of our time.

Engaging all the senses in a single artwork has been the great dream for artists for more than a century. From *The Ring*-cycle operas of Richard Wagner, which premiered from the 1850s to the 1870s, to the rock concert and light shows of the

1960s and the virtual reality equipment of today, artists strive to entrance their audiences. They attempt to create experiences so overwhelming, so all-encompassing, that normal, daily reality disappears. Rimbaud, in that sense, heralds not only the hippies, but multimedia. The derangement he sought in drink and sex is not so different from what cyberpunks seek in digital sight and sound.

If art is the new religion, what of the old? The German philosopher Friedrich Nietzsche took up Rimbaud's challenge to envision a "revolution in morals." He was also, initially, a great admirer of Wagner's. But he went much further in his thinking. "God," he announced, "is dead." Christianity was a "slave morality" that had to be discarded. War was glorious, and the new age belonged to supermen who used their "will" to invent their own rules. Art, too, had to change. Ugliness, not beauty, made art profound. And its sources were sexual, not moral. "All kinds of ecstasy . . . have this power to create art, and above all the state dependent upon sexual excitement." To this day, Nietzsche's sharp psychological insights and extreme views appeal to many avant-garde artists.

One entire wing of the avant-garde springs from Nietzsche and nihilism, a related philosophy with Russian roots. Nihilists believe that morality is meaningless and that existing governments and laws should be eradicated. As an approach to art this takes two forms. Artists with darker, grimmer temperaments view destruction and violence as the only art of our time. Those who have a better sense of humor enjoy seeing all of our senseless activities as funny.

Between bombing-mad anarchists and mischievous absurdists the careful borders that a frame, a stage, or a book jacket placed around art were disappearing. But artists continued to make art, and avant-garde artists had to figure out how to use these new ideas to comment on their time. Art as religion and art as destruction both asked much from their audience, which quickly learned its part.

Alfred Jarry came to Paris as a teenager and took the next step past Rimbaud. Influenced by anarchism, he invented his own fantastic form of science called 'pataphysics. He refused to believe in normal reality and behaved as he pleased. He painted his hands and face green, wore high-heeled shoes when he could not find any others, and wrote a play designed to attack its audience. Jarry's *Ubu roi* was

first produced in 1896 and is still sometimes performed today. It began with an altered obscenity and proceeded to make fun of the very teachers who were preaching reason and progress throughout France. One solution for the avant-garde, then, was to make absurdity a virtue and shock a part of their art. Just as Rimbaud wanted to invent an impossible language, Jarry created a science that denied reason.

By this time, the radical artists discovered a new set of cafés in a seedy part of Paris called Montmartre. Even as they rejected convention they were aware of the publicity value of their antics. Le Chat Noir (the Black Cat) published its own newspaper and, when the café moved to a larger space, held a wild and highly publicized parade. The old location was taken over by a singer named Aristide Bruant. Prints of the poster Henri Toulouse-Lautrec made for Bruant can be found in any poster store today.

This woodcut by Jarry showed his mocking image of Ubu Roi.

(Courtesy the Jane Voorhees Zimmerli Art Museum, Rutgers, The State University of New Jersey, acquired with the Herbert D. and Ruth Schimmel Museum Library Fund.)

Bruant insulted customers when they arrived, which only made his café more popular. Making fun of people, assaulting their beliefs, creating a scandal, and having a grand old time blended together in the new avant-garde, so much so that some even turned the new art on itself. As painters claimed that art was just strokes of paint, a writer tied a brush to a donkey's tail and sold the resulting painting for both the money it brought and because it made a great story.

Rite of Spring, Rite of Death

Debussy's **Afternoon of a Faun** *belongs here, followed by Igor Stravinsky's music for* **Rite.** *They are astonishingly different. The Joffrey Ballet's reconstruction of* **Rite** *is available on video.*

Exactly one year before the premiere of *Rite of Spring,* Nijinsky appeared in *Afternoon of a Faun.* The ballet's central moment came when the dancer, dressed in a skintight costume, simulated sexual release on-stage. After that outrage; after *Hernani, Olympia,* and *Ubu roi*; after Baudelaire and Rimbaud; after total art and absurd art, how could *Rite of Spring* still have disturbed anyone at all? How did it come to be seen as the most shocking event of all time when people were accustomed to being served insults with their drinks? The answer is in the piece itself. *Rite* not only captured the real challenges in all of the pre-

vious scandals, it looked ahead to crises of the rest of the century. It was a shattering experience.

Nijinsky's choreography for *Rite* was quickly lost and only partially reconstructed by a diligent dance historian in the 1980s. Until Millicent Hodson devoted herself to the task, scholars based their image of the dance on the memoirs left by people who saw it. But these were incomplete and contradictory. Through amazing detective work Hodson found seventy lost pencil drawings by the artist Valentine Goss that showed various moments in the piece, as well as musical scores with notes taken during rehearsals. Though she could not account for every step, in 1987 she was finally able to restage Nijinsky's *Rite.* The performance explained what took place seventy-four years earlier.

The original idea for the piece may have come from the composer. In 1910, Stravinsky had a vision of "a solemn pagan rite: sage elders, seated in a circle, watched a young girl dance herself to death. They were sacrificing her to propitiate the god of spring." On one level, *Rite* re-created the ancient, pagan world in which the group ruled and the individual counted for nothing.

Goss's sketches showed how Stravinsky's vision

In *Afternoon of a Faun* Nijinsky moved only in profile, as if he were a figure painted on a Greek vase. The tension of his total control and the lush music only made the piece more erotic. In *Rite* the dancers' motions were even more angular, and the music was now harsh and dissonant. (Photo used with permission and is copyright Eakins Press Foundation.)

Jean Cocteau, a poet and avant-garde creator in his own right, drew this sketch of Stravinsky playing *Rite of Spring* on the piano. It captures both the pounding rhythm of the piece and its effect on everyone who heard it.

(© 1998 Artists Rights Society, NY/ADAGP, Paris.)

was carried out on-stage. Men were separated from women, the young from the old, and all moved in groups, often in circles. This was a primitive society in which everyone's role was defined from birth to death. The only individual was the girl, and she was doomed. The rebirth of spring offered no personal hope or salvation. This was no Passover or Easter. People had no control over the seasons, they could only submit to them. Spring was a violent eruption of the earth that the tribe bought with blood.

Not only did Hodson recover some of Nijinsky's choreography, she learned a lot about the costumes and makeup the dancers wore. The heavy makeup made them look all the more interchangeable. Everyone of the same rank within the tribe wore the same costume. As one critic described the 1987 performance, "young women in red, young women in blue and white, young men in white and green, young men in white and orange and purple, young men in white and red. As the groups become animate one by one, the dancers never move except in unison with their color team." But how did they move?

While he was working on *Rite,* Nijinsky studied eurythmics, a practice that sought to fuse move-ment and music. This was another attempt to unite the arts, as we saw in Rimbaud. The motions Nijinsky invented were in keeping with the score, yet this only made them more difficult for people to watch. Dancers moved in angular, off-center ways. Their toes pointed like puppets' feet, their stiff hands more like spades than fingers, the dancers looked like machines even as they were enacting a primitive rite. This was the ultimate challenge of *Rite of Spring.*

For eighty years the avant-garde had spread out in a great pincer movement that challenged every safe and comforting belief. *Rite* announced that the two sides had joined. On the one hand, people such as Nietzsche and Rimbaud undermined the rules of civilization. The ancient and horrible laws of nature—the primitive, barbaric drives within all of us—had never been tamed. Comfortable middle-class life was a paper-thin fraud that any sensitive artist could expose. This was the truth that the tribe told. On the other hand, science, reason, progress, mechanical life were inevitable. The camera made hundreds of years of art training useless. Skyscrapers, cars, planes erased the difference between Paris and the countryside. The mass of men worked in

Picasso's *Demoiselles d'Avignon,* painted in June and July of 1907, is one of the most terrifying and important paintings of the century. Using traditional African masks as European faces did many things. "Primitive" and "civilized" changed places in this depiction of prostitutes who are frightening on a level that goes far beyond *Olympia.* As great empires spanned the world, and as rules of art reversed, inner horrors took over outer appearances.

(8' x 7'8". Courtesy the Museum of Modern Art, New York. Acquired through the Lillie P. Bliss Bequest and © 1998 Estate of Pablo Picasso/Artists Rights Society, NY.)

Braque and Picasso together and individually invented cubism. In the spring of 1912, Braque painted this bottle he titled *Soda*.

(14¼" diameter. Courtesy the Museum of Modern Art, New York. Acquired through the Lillie P. Bliss Bequest.)

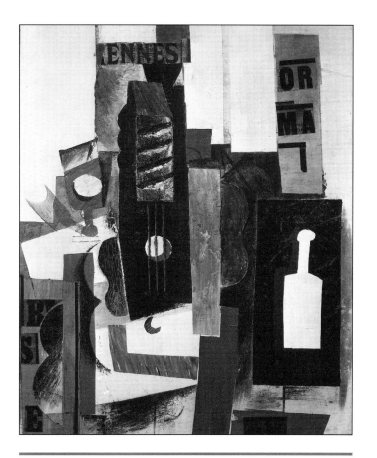

Picasso's early 1913 work *Glass, Guitar, and Bottle* is a classic cubist creation on the border between collage and painting.

(25⅓" x 21⅛". Oil, pasted paper, gesso, and pencil on canvas. Courtesy the Museum of Modern Art, New York. The Sidney and Harriet Janis Collection and © 1998 Estate of Pablo Picasso/Artists Rights Society, NY.)

factories, pulling levers like the human rods and pistons on-stage. This was the truth of the radically new music and the strange angular gestures. Between the subhuman pull of the unconscious and the inhuman demands of modern life there was nothing left, only rituals of violence.

The clash over the Armory Show in New York, the riot on the opening night of *Rite of Spring,* showed how difficult it was to absorb this prophetic message. But history is crueler than prophecy. One year later the entire world learned how right the artists had been. The good-natured disputes over *Nude* were replaced by the most horrific world war.

World War I began in 1914 and lasted four long years. A war fought to "make the world safe for democracy" resulted in ceaseless death and destruction. Everything the radicals claimed was hidden by the old lineup of art, life, and morals burst forth in the trenches. Men were beasts. The individual counted for nothing. The mangled bodies of victims and veterans made the most distorted prewar paintings seem tame. Even more haunting were the trenches themselves: they turned the landscape of Europe into a cubist canvas. If few saw the link at the time, many sensed that the defenders of the old morals were horribly wrong, and the radical artists—whose work had seemed to deny normal reality—so very right. In its greatest moment of glory, the avant-garde predicted the future, only to be consumed in the very flames it foresaw.

Art Is Dead

Edgard Varèse's Amériques *can sound like a midpoint between Stravinsky's* Rite *and the noise music of Zurich Dada; Cabaret Voltaire, a 1980s punk group, consciously looked back to these Dada roots; Tom Stoppard's play* Travesties *explores all of the Zurich revolutions at once.*

Zurich, February 1, 1916

Do you doubt the death of art? Listen to the German doctor-poet Richard Huelsenbeck in 1916:

This is how flat the world is
The bladder of the swine
Vermilion and cinnabar

Cru cru cru
The great art of the spirit
Theosophia pneumatica
Poeme bruitiste performed the first time by
Richard Huelsenbeck Dada
Or if you want to, the other way around
Birribumbirribum the ox runs down the circulum

. .

What was going on?

On Feb 1, 1916, a German playwright named Hugo Ball opened a combined café, theater, and art exhibition space in Zurich, Switzerland. The Cabaret Voltaire, as he called it, was the birthplace of a movement of art and anti-art that is still strong to this day. Or it was *a* birthplace. Dada could have no single origin. A good case could be made for the futurists in Italy just before the war or for Duchamp and his friends in New York in the earlier

Hugo Ball
reciting in the
Cabaret Voltaire
in 1916.

(Courtesy
Rudolf Kuenzli and
the International
Dada Society.)

KARAWANE

jolifanto bambla ô falli bambla
grossiga m'pfa habla horem
égiga goramen
higo bloiko russula huju
hollaka hollala
anlogo bung
blago bung
blago bung
bosso fataka
ü üü ü
schampa wulla wussa ólobo
hej tatta görem
eschige zunbada
wulubu ssubudu uluw ssubudu
tumba ba- umf
kusagauma
ba - umf

Hugo Ball
delivers the
poem "Karawane"
—written out
on the picture—
as part of a Dada
evening.

(Courtesy Rudolf
Kuenzli and the
International Dada
Society.)

teens. Paris has to be part of any avant-garde mix, and soon Germany would add its claims. Some even think of Mark Twain as Dada's spiritual father. Let's start at the Cabaret Voltaire.

Of an evening, Emily Hennings, Hugo Ball's lover and an avant-garde performer in her own right, sang. A Romanian poet named Tristan Tzara recited. On display were the latest and most provocative paintings by people such as the metaphysical Italian Giorgio de Chirico or the ever-challenging Picasso. Soon artists began to gather and hold evenings devoted first to Russian and later French literature. These were no sedate poetry readings. Huelsenbeck was passionate about what he thought of as "negro music," especially the tom-tom drum. According to Ball, he wanted to "drum literature into the

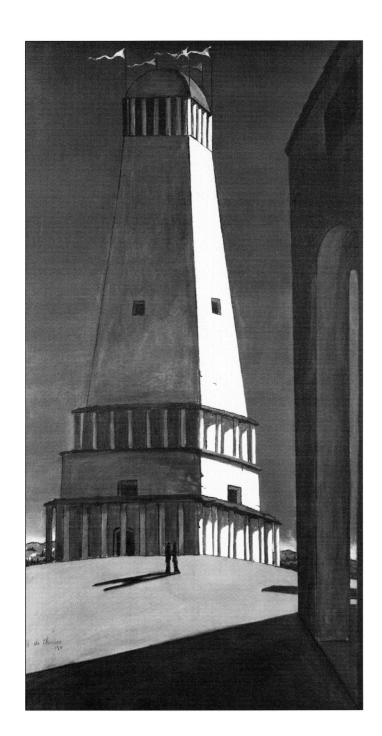

The Italian painter Giorgio de Chirico made the combination of faceless people and haunting places so evocative that his clearly drawn scenes seem dreamlike and full of portent. His *Nostalgia of the Infinite* may have been painted in 1913 or 1914, though it is dated on the work 1911.

(53¼" x 25½". Courtesy the Museum of Modern Art, New York.)

ground." And, as Ball wrote in his diary on May 15, the group was starting a magazine with an unusual name: " 'Dada' ('Dada'). Dada Dada Dada Dada."

Like the movement, the name has many explanations and reputed origins. *Dada* is the French word for rocking horse, which Tzara may have discovered in a random glance in a dictionary. Both chance and the childlike fit Dada. *Da da* is Romanian for "yes yes," perhaps overheard when Tzara talked with his friends. That suits a movement open to anything. Dada has been found to have other meanings in an African language and in Italian. The sculptor Hans Arp, who was in a position to know, gave a Dadaist explanation: "I hereby declare that Tzara invented the word Dada on 6th February 1916, at 6 p.m. I was there with my 12 children

when Tzara uttered the word . . . it happened in the Café de la Terrasse in Zurich, and I was wearing a brioche in my left nostril."

Dada evenings involved many kinds of music and performance including the "bruitism" Huelsenbeck referred to. Invented by the futurists, this was a kind of noise music designed to confront, annoy, and challenge the audience. It brought the noise of the street into art. Huelsenbeck's poem went on and on, including words in a variety of languages and nonlanguages. It featured lines like "the vicar again he closes his pants ratplan," and "voilà the lake Orizunde how he reads the New York Times."

In such a poem, language, religion, or any kind of familiar meaning is lost. Strange tongues, real and invented, intrude on normal speech. Just as painters such as Picasso used African masks to reinvent European paintings, Dadaists included what they thought of as African rhythms, sounds, even words, in their performances. They even wore their own versions of those same masks. Why? Why was language falling apart to be replaced by rhythm, nonsense, noise, pidgin, and masks?

The war that was consuming Europe was not just between nations, but between empires. Eng-land, Germany, and France all held overseas colonies (as did the United States). Most Europeans thought this made sense. They believed that superior white nations could bring civilization to what they considered backward and savage peoples. But the artists were showing a reverse story. The art, the rhythms, the look and sound of the colonies were washing over Europe. As the empires destroyed themselves in war, their vaunted civilization was either collapsing into a gibberish, a babel of tongues, or finding wild new energy in the art of its conquered peoples. Dada was both destruction and celebration, both assault and playful whimsy. And that, too, echoed its times.

The generals and statesmen who conducted World War I made many horrible mistakes. Blinded by their dream of a great frontal attack that would sweep the enemy away, unwilling to acknowledge the destructive power of machine guns and poison gas, totally callous to the men in the disease-ridden trenches, they demanded attack after foolish, bloody, wasteful attack. In 1916, for example, 320,000 German soldiers and 348,000 French were killed in the ultimately inconclusive Battle of Verdun. In the fighting for Ypres in 1917, the British lost over

300,000 men and gained a total of five miles of territory. That was "reality." For Dada, then, to be both destructive and playful was not so strange. In neutral Switzerland, which was insulated from but surrounded by the war, the artists emulated and exposed its absurdity.

Life was irrational and violent, why shouldn't art be? The words of great leaders made no sense, why should poetry? As Ball explained, "the paralyzing horror which is the backcloth of our age is here made visible." Hans Arp was even more explicit.

Revolted by the butchery of the 1914 World War, we in Zurich devoted ourselves to the arts. While the guns rumbled in the distance, we sang, painted, made collages and wrote poems with all our might. We were seeking an art based on fundamentals, to cure the madness of the age, and a new order of things that would restore the balance between heaven and hell. We had a dim premonition that power-mad gangsters would one day use art itself as a way of deadening men's minds.

This *Caricature of a Futurist Evening* by Umberto Boccioni was drawn in 1911. The confusion of speakers, music, and wild art looks ahead to both Dada and the Happenings of the 1960s.
(Photo appears without credit in Tisdall, *Futurism*.)

"Abolition of Logic: DADA"

The Rose-croix pieces of the French composer Erik Satie are based on Rosicrucian mysticism. Satie's scores are as interesting as art objects as they are as plans for musical performances. Keep Satie in mind again when we get to surrealism.

Hans Arp's statement shows the double nature of Dada. In one way, viewed, say, by a conventional middle-class person who wandered into the Cabaret Voltaire, Dada itself seemed to be violent, destructive, chaotic. And certainly artists like Tzara were exactly that. Tzara aimed to infuriate the audience, making their anger part of the performance. Yet, at the very same time, Dadaists were desperately trying to save art, life, the future from the violence around them and the gangsters waiting in the wings. They acted irrationally to save themselves from the supposedly rational men who were butchering Europe. They were playful, mischievous, and difficult in order to save art from the manipulators who were eager to use it to make money or to numb people's minds.

Dada was both art and anti-art. Tzara showed this in a 1918 manifesto: "Abolition of logic: DADA . . . abolition of memory: DADA . . . abolition of the future: DADA . . . Liberty: DADA DADA DADA, the roaring of contorted pains, the interweaving of contraries and of all contradictions, freaks and irrelevancies: LIFE." This was an immensely creative and totally unstable combination. While Dada art remains fresh and even innocent today, it is also the direct ancestor of the most violent, destructive, and self-destructive art of our time.

The Dadaists blended poetry, masks, performance, music, insult, sense, and nonsense together. At the Cabaret Voltaire all of this took place simultaneously. Three or four people spoke at the same time, adding songs, sound effects, and random noise at their will. What people heard was unpredictable, a product of the moment, and hardly comprehensible. That was the point. Hugo Ball explained that such simultaneous poetry "carries the message that mankind is swallowed up in a mechanistic process. . . . It represents the battle of the human voice against a

world which menaces, ensnares and finally destroys it, a world whose rhythm and whose din are inescapable." Inescapable din—this was yet another attempt to create a total and consuming art experience.

One of the artists whose work was on display at the cabaret was the Russian painter Wassily Kandinsky. While the Dadaists submerged their audience in a simultaneous assault (you might call it the art version of the attacks on the trenches), Kandinsky was trying a different version of total art in Germany. He combined a mystical belief called theosophy, color theory, and painting in what Ball termed an effort "to bring about the rebirth of society through the union of all artistic media and potentialities." Kandinsky, exactly like the acid-rock bands of the sixties and the Deadheads who still emulate them, was after *synesthesia*. This was a state in which you could listen to color and watch sound. The explicitly mystical idea behind this was that art as a distinct and separate thing would come to an end, yet we could continuously perceive the world as the most intense and multisensory art. While the

This 1913 watercolor by Kandinsky can seem to be a random doodle, but it has an internal order all of its own—which is all the more striking when you see it in color. (12⅝" x 16⅛". Courtesy the Museum of Modern Art, New York. Katherine S. Drier Bequest.)

Dadaists were making noise to match the din of the trenches, Kandinsky was choosing colors that sounded like the dawning of a new age.

Kandinsky's mystical color theories implied that there was some higher spiritual truth that proved all the rest of both art and life false. Abstract art was like true life, precisely because it did not look like normal life. If you know—as many of these artists claimed to know—that a new stage of human existence is coming, then all the counterclaims of train schedules, tax laws, and military maneuvers are so many lies and illusions. If art was to be true to life, it might just have to enter the hazy world of the occult. But where did science end and mysticism begin?

Our forbears read about wild new inventions that sent sound through the air, strange new theories that made all of physics "relative," and disturbing new studies that uncovered sexual and violent feelings in the smallest child's dreams. How could they know what revelation would come next? To many people, electricity seemed magical. Why shouldn't color be just as powerful? Which was more illogical, x-rays that could see through bodies or synesthesia that merged the senses? As Benjamin

de Casseres put it in 1912, "in poetry, physics, practical life, there is nothing . . . that is any longer moored to a certainty, nothing that is forbidden, nothing that cannot be stood on its head and glorified." For some avant-gardists, art was like the alchemists' crucible in which the common lead of daily routine could be magically transformed into spiritual gold.

But the link of art and life could also go in just the opposite direction. It could suppose that there is nothing more to existence than a happenstance mixture of people, places, and events. Instead of revealing some higher truth, art might just be the jumble of three poets speaking at once. Dada explored both of these possibilities, often at the same time.

One of Dada's key discoveries was chance, and one of its main products was collage. According to legend, Arp was working on a drawing that he could never quite get right. Angry, he tore it up and tossed away the pieces. Later that day he noticed how they had fallen, and the new pattern they made all on their own. He loved it. Chance (or was it some stronger force such as his unconscious?) had created a much better design than he

could using only his conscious mind. This was just like the simultaneous poetry that engulfed the audience but existed only in the moment. By literally taking art out of the artist's hands the Dadaists made it both a snapshot of the moment and a conduit to the unseen. From that day to this, avant-garde artists have added chance to their arsenal of tools. Chance disrupts any effort of the artist to tell a grand story. Unless, like some ancient seer looking at the entrails of a slaughtered animal, you see a higher truth in the fragments.

Animated by this belief in chance, the Dadaists began making use of anything and everything around them. They cut up magazines, glued down pieces of fabric, and looked at the world like wide-eyed children. Ball explained in his diary that "it was an adventure even to find a stone, a clock-movement, a tram-ticket, a pretty leg, an insect, the corner of one's own room." Art was "no longer a 'serious and weighty' emotional stimulus, nor a sentimental tragedy, but the fruit of experience and joy in life." By picking up pieces of the "real" world and making them part of their art the Dadaists both enriched their art and made their lives more interesting. This is exactly like sampling in rap. Sound

collages that use existing recordings bring the rest of life, the real world of overheard tunes, noise, and violence, into the music. But in rap the sampling is under the control of a mix master. It is not random and does not take over. That is why rap is tamer than Dada, and why you can dance to it.

Just as the mystical artists' faith in a higher truth matched popular beliefs, the Dadaists' fascination with chance echoed outside of their small circle. In 1913 the Danish physicist Niels Bohr published the paper that became the cornerstone of quantum physics. His German colleague Werner Heisenberg added an important insight about uncertainty in 1927. The theory they were developing placed chance at the heart of all existence. Atomic particles were not like colliding billiard balls or tiny planets revolving around a sun. Instead, they were the scene of unpredictable chance events. Human observers would, by definition, never be able to know both the precise location and exact speed of these events. If they knew one, they had to guess the other. Quantum mechanics, a practical application of these theories, is widely used today. But Albert Einstein, the brilliant inventor of the theory of relativity, could never accept it. God, he claimed,

"does not play dice." Either way you looked at it, the Dadaists were on to something. If the quantum physicists were right, chance art mirrored the most basic reality of the universe. If Einstein knew better, the most random collages were actually fine creations that paralleled the work of the Lord.

Collage is now a standard form of art. And the spirit of collage is still central to one definition of the avant-garde. By breaking off pieces of the flood of things and ideas around us, collage subverts the stories the world keeps trying to tell us. Collage is an unwillingness to take anything straight. It celebrates the quirky, the oddball over the monumental.

For some Dadaists this mood went even beyond collage. If a found object, something that you happen to notice in a magazine or on the street, is interesting in itself, why does it have to be part of a collage to be art? Why not just call the found object art? In Paris and then New York, Marcel Duchamp, whose *Nude* was the flash point of the Armory Show, did just that. So what if others saw one piece as a wine rack, another as a urinal? To Duchamp these "readymades" became art once he saw them that way. Signing the readymades, especially with a provocative made-up name, also helped. In a sense,

Signed "R. Mutt," this readymade—which Duchamp entitled *The Fountain*—was rejected from a 1917 exhibition designed to be open to all new art. The photographer, Alfred Stieglitz, was himself a leader of the American avant-garde.

Another Duchamp readymade, *Bicycle Wheel* was first made in 1913—which means it was slightly more crafted than a true found object. There are many "artistic" aspects of this creation, such as the counterpoint of the two circles, and the two confined spaces between the spokes of the wheel and between the legs of the stool. This version was re-created in 1951.

(Courtesy the Museum of Modern Art, New York. The Sidney and Harriet Janis Collection and © 1998 Artists Rights Society, NY/ADAGP, Paris/Estate of Marcel Duchamp.)

Man Ray's 1921 photo of Duchamp's *Tonsure*, a haircut in the form of a comet.

(Courtesy the Philadelphia Museum of Art: Alice Newton Osborne Fund and © 1998 Man Ray Trust/Artists Rights Society, NY/ADAGP, Paris.)

by signing a wall a graffitist does something similar, making the wall into art by putting his name on it. But, since the name is generally spray painted in an attention-getting "artistic" fashion, this is a more

traditional form of public art. The name, not the wall, is the art. For Duchamp, the artist's eye served as a magical camera, transforming anything into art. Dadaists of this sort behaved like mad prank-sters, bohemian clowns, overturning at every moment the sober rules of the sober world.

Zurich Dada was perched at the fragile point where chance as play and chance as oracular truth met, where rebellion and prophecy overlapped. This balance could never last, in part due to three grim plotters who were refining their own perfect new truth just across the street.

The Cabaret Voltaire was located at number one Spiegelgasse. Diagonally across the street stands number twelve. Three studious men were staying in

Man Ray's 1924 photo *Duchamp Dressed as Rrose Selavy* was a multilingual pun. Pronounced in French, the name announced that Eros, or sex, is life (*éros c'est la vie*). The photo did not imply anything about Duchamp's sexual preferences, just that he preferred to have sex.

(Courtesy the Philadelphia Museum of Art: The Samuel S. White III and Vera White Collection and © 1998 Man Ray Trust/Artists Rights Society, NY/ADAGP, Paris.)

an apartment there and sometimes came by to enjoy the goings-on at the cafe. Yet Grigori Zinoviev, Karl Radek, and Vladimir Ilich Lenin were planning a far more serious challenge to the bourgeoisie. They were preparing for the Communist takeover of the Russian empire, and after that, for the total transformation of human life. On two sides of the same narrow street Dadaist anarchists and the architects of Soviet dictatorship mapped out their world-shaking revolutions.

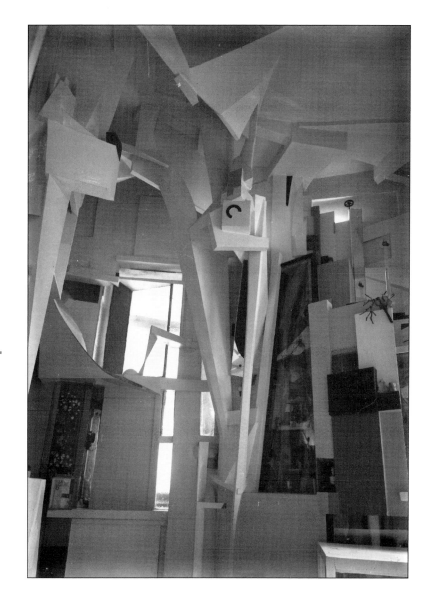

Kurt Schwitters was a German Dadaist. He made art out of the bits and pieces people throw away every day. Schwitters called his art *merz*, a made-up word that comes from the second half of the German word for *commerce*. What is leftover from business is merz, which is thus art. This strange building was his cathedral of everyday objects and was almost entirely filled with his creations. It was destroyed during World War II.

(1933 photo courtesy Sprengel Museum, Hanover.)

An Icon for Our Times

Alexander Scriabin made a number of attempts to unite the arts and to link music and philosophy. His Divine Poem *and* Prometheus: The Poem of Fire *(which was to be accompanied by an organ that produced colors) suit this section.*

Petrograd (St. Petersburg), December 1915

"The Last Futurist Exhibition," announced the poster for the 0.10 (zero ten) art show in Petrograd (now Saint Petersburg). Futurism was an Italian art movement that celebrated the speed, mechanism, and violence of modern life.

Filippo Marinetti, the founder of the movement, was a great propagandist, and the most advanced Russian artists read his polemics and tried out his experiments with liberated language. But this December 1915 event was not designed to be the "last" of anything. Instead, it was the unveiling of suprematism, Kazimir Malevich's effort to take art beyond all known boundaries. This was not just a matter of style. Like Kandinsky, Malevich thought that breakthroughs in art were linked to changes in thought. He wanted to create art that would take humanity to a new stage of existence. Suprematist art would lead us into the fourth dimension.

Two years earlier Malevich designed the sets and costumes for an opera that indicated what the new fourth-dimensional world would be. *Victory over the Sun* featured music by Mikhail Matiushin and text by the poet Alexei Kruchenykh. Kruchenykh did not create conventional poetry.

Instead he wrote *zaum* or "transrational" works such as this:

> *i*
>
> *che*
>
> *de*
>
> *mali*
>
> *gr*
>
> *iu*
>
> *iukh*
>
> *ddd*
>
> *ddd*
>
> *se*
>
> *v*
>
> *m'*

In 1922, Velimir Khlebnikov, scheduled to take part in the team working on *Victory,* wrote a piece in which a superhuman figure who could understand the speech of animals, insects, gods, and stars spoke in *zaum*. Here is a monologue from *Zangezi: A Supersaga in Twenty Planes*:

> Mara-roma
>
> Beebah-bool
>
> Oook, kooks, ell!
>
> Rededeedee dee-dee-dee!

Peeree, pepee, pa-papee!

Chogi, goona, geni-gan

Ahl, Ell, Eeell!

Ahlee, Ellee, Eeelee!

Ek, ak, oook!

Gamch, gemch, ee-o!

rr-pee! rrr-pee!

Zaum posed some important questions. Usually poetry is based on familiar rules of grammar, established dictionary definitions, and the classics of literature. Might not all of those conventions trap the poet? What might emerge if they were entirely disregarded? What is language anyway? Why does this part of this sentence make sense and dldldjoomngomneholmomwpuj not? Only because over centuries we have agreed that is so. But perhaps in those moments where language breaks down—in a baby's babble, in the riffs and ravings of the insane, in the glossolalia of the inspired or possessed—there might be a truer and deeper language. Perhaps the poet who found or made this language could create poems that went past the mind into the deepest centers of being, where sound is feeling. *Victory over the Sun* was about defeating all the familiar laws of earthly life. Using transrational lan-

guage was one step. In the 0.10 exhibition Malevich wanted to go even further past old boundaries. To ensure that his exhibition would achieve this aim, he planned it out very carefully.

Thirty-nine canvases by Malevich and other radicals covered the walls. He reserved a very special place for the most extreme one of all. The vast majority of Russian Christians were believers in the Russian Orthodox faith. In Orthodox churches icons, or images, of sacred figures are extraordinarily important, and they always stand in the same spot in the church. Malevich put his *Black Square* in the place of the icon, at the highest point where all eyes would see it. This was a painting that had gone totally beyond imitating the world. It was a black square with a white border. Nothing more. Pure form had replaced all imagery, even the abstractions of the cubists. And, the placement declared, this new total abstraction was sacred.

A pure shape, a painting that eliminated all description, theme, or subject, took the place of God. El (Lazar) Lissitzky, another talented and extreme young artist, explained that "for us SUPREMATISM . . . stood revealed for the first time in all its purity the clear sign and plan for a definite new

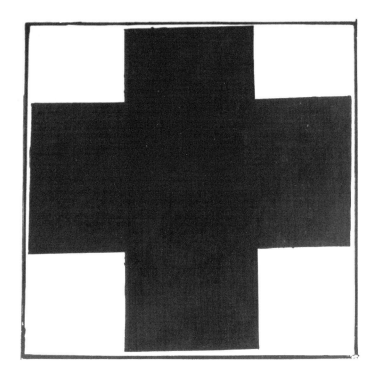

Malevich's *Cross* shows his suprematism in action: the form of the square is its content.
(6⅛" x 6⅜". Courtesy Leonard Hutton Galleries.)

world never before experienced—a world which issues forth from our inner being."

The only way to get a sense of how shocking this was is to combine two more recent challenges. Malevich's canvas showed an image that had never

been seen before. Never. No artist anywhere had thought to make a painting that was just a shape. This was a work of art that did not refer to anything else in the surrounding world. Painting was now as separate from society as *zaum* poetry was from conventional language. Even today when each generation of computer chips exponentially expands the range of what we can see on our screens, we only experience evolutionary change. It becomes easier to do more, but we know what to expect. Thirty-two-bit games were just more three-dimensional versions of their sixteen-bit ancestors, which is why they failed. The promise of virtual reality is that it will give us totally new, and unexpected, experiences. Malevich was just that novel, and more.

Recently, Andreas Serrano created a work called *Piss Christ* in which a photograph showed a statue of the crucifixion floating in the artist's golden-hued urine. That was one of the pieces that most infuriated Senator Jesse Helms in 1989. In Malevich's day, hanging a radical painting in the place of the icon was just as shocking. Both artists draw on the deepest roots of religion to lend power to their art. The difference is that Malevich created

The 0.10 exhibition, with Malevich's suprematist masterpiece in the place of the icon (upper right corner).

a radically new form of art as an expression of his new faith, while Serrano was being radical in order to express contempt for the faith he was born into. One was utopian, the other bitter. Still, for many, art that simultaneously gave the world a totally new

experience and announced that it was taking the place of religion was abhorrent.

Alexander Benois, a well-known Russian artist and art critic, frequently wrote about vanguard art exhibitions. Though he often severely criticized them, he attempted to understand their aims. But *Black Square* and its placement were of another order. He repeatedly called the show "blasphemous." Malevich's exhibition was the sign of a terrible new way of thinking that worshiped reason. In place of a human art, it offered a "horrific means of mechanical 'renewal' with its machinishness." Rebirth, the promise of Christianity, was now in the hands of machines and the machine mentality. If pure form was liberating, it only freed people to lose their souls and turn into mechanical objects. Once people gave way to this new mentality, there would be grave consequences. *Black Square* preached "a sermon of zero and death." Malevich's pride, expressed even in calling his movement suprematism, would bring down all of the biblical punishments. "It asserts itself though arrogance, haughtiness, and by trampling over all that is dear and tender; it will lead only to death."

Malevich reacted strongly to Benois's critique, and in the process, he demonstrated the problem the avant-garde so often poses for those who study it. He was arrogant, defiant, perhaps heroic, and yet he left words that serve as the most telling proof that, in some sense, Benois was horribly right:

I possess only a single bare, frameless icon of our times . . . and it is difficult to struggle.

But my happiness in not being like you will give me the strength to go further and further into the empty wilderness. For it is only there that transformations can take place.

And I think you are mistaken when you say in reproaching me that my philosophy will destroy millions of lives. Are you not, all of you, like a roaring blaze that obstructs and prevents any forward movement?

From the standpoint of art and art history, Malevich won this exchange hands down. A fearless explorer, he dared the "wilderness," underwent a "transformation," and created a brilliant "icon of our times." His art is as fresh today as Benois's is dated. And yet in terms of political and social history he was fatally wrong. The "philosophy" he espoused, along with the regime the three Zurich

plotters brought with them to Russia, did "destroy millions of lives"; millions upon millions. In the end, it nearly destroyed his art.

Just like the American conservatives who saw an assault on middle-class values in the art of the Armory Show, Benois recognized what was truly at stake in suprematism. The habit of mind that could see pure inhuman form as liberation could also accept the impersonal laws of Communism as a solution to all human ills. As Lissitzky put it, "into this chaos came suprematism extolling the square as the very source of all creative expression, and then came communism and extolled work as the true source of man's heartbeat." Benois was like a prophet, seeing the ranks of skulls doomed by Lenin and Stalin grinning in the pure white of Malevich's painting. But was the art really at fault? Did *Black Square* bring on the Communists, or did it make visible the world in which they would thrive? Was "machinishness" a view that Malevich imposed or a tendency that he captured and revealed?

The avant-garde is, and is meant to be, disturbing. Is that because it aims to shock us, or because it forces us to see the shocking world in which we already live? Avant-gardists *are* often arrogant. They trust their own walks in the wilderness, not the safe homes and streets of civilized society. Does this free them to bring back prophetic visions or damn them to worship delusions and inflict nightmares? The Soviet avant-garde lived out all of these conflicting stories.

Machines

Though composed long after the event, Sergei Prokofiev's Cantata for the Twentieth Anniversary of the October Revolution is particularly appropriate for this section as well as for the next chapter. It attempts not only to depict Lenin's revolution but to do so according to the artistic principles of Communism as they had come to be defined by Joseph Stalin. The second song, which is quite beautiful, is unintentionally hilarious. Theremin: An Electronic Odyssey (1993) is an excellent documentary that fits this section.

Benois was not merely prophetic in forecasting death, he identified the key term in the new thought: "machinishness." The futurists were great advocates of machines and they were not at all drawn to Communism. But Soviet Communism brought machine worship to new heights. Once in power the Communists made it a priority to change Russia from a nation in which 80 percent of the people worked on farms and lived by almost medieval traditions into a modern industrial giant. This was necessary in order to make the Soviet Union a strong world power. According to Lenin, this miraculous improvement would be accomplished by transforming "the whole of the state economic mechanism into a single huge machine." But it was also a product of the theories of Karl Marx, which decreed that true Communism would only arise from industrial workers.

One of Marx's most profound insights was that the nature of any given society could be explained by how goods were produced and who owned the means of production. In a nomadic society people had one set of beliefs, in a farm economy another. When machines and factories dominated, they brought about wholly new ways of life. Though in one sense Marx's vision told a terrible story of increasing oppression driven by economic change, it had a happy ending. When enough people reached a certain stage of industrial economy, when a critical mass of workers were crushed by the ruling class, a revolution would inevitably come and usher in the final, glorious stage of human life.

History itself, then, was a kind of machine driven by an economic engine. Whether they glorified machinery or explained the mechanical laws of history, the Communists were obsessed with machines.

Lenin embraced Marxism but added his own twist. Since Russia was not well industrialized it did not seem ripe for revolution. But in another sense it truly was. From the beginning of the century, Czar Nicholas II and his advisers faced an insoluble problem: they, too, knew that Russia must build factories in order to compete with other nations. And many also realized that in a new Russia more and more people would demand political and legal rights. Yet the czar also believed that his entire rule depended on being an unquestioned autocrat, and most peasants agreed. The fact that the regime's

This 1923 Lissitzky lithograph titled *Sentinel* shows an almost human machine. In the twenties, machinery seemed so new, powerful, and alive that to many artists it had personality. It is no surprise, then, that the Czech author Karel Capek invented the term *robot* in 1920 in his play titled *R.U.R.*

(21" x 17½". Courtesy Leonard Hutton Galleries and © 1998 Artists Rights Society, NY/VG Bild-Kunst, Bonn.)

critics and opponents became increasingly violent in their actions and radical in their demands only confirmed this belief. Year after year the unstoppable force of political and economic change pushed against the immovable object of peasant traditions and czarist rigidity. A terrible quake was sure to follow, and everybody knew it. In 1908 the poet Alexander Blok wrote that "we do not know yet precisely what events await us, *but in our hearts the needle of the seismograph has already stirred.*"

With a country so tense, and divided between ruler and ruled, Lenin decided that Communism could arrive in a new and different way. If a small, tightly organized, and totally committed group held the right understanding of history it could take over the nation and serve as the leading wedge of new thought. It could behave in the interest of the people, even if the people disagreed. The Bolsheviks, as Lenin's group was called, were very

Nikolai Kolli's *The Red Wedge* was designed for the first anniversary of the Russian revolution. Communism, like the avant-garde, cracks open established reality.

(Pencil, watercolor, India ink. 33 cm. x 20.5 cm.)

much like the avant-garde. They grasped truths no one else could see, and this gave them the right to ignore or despise anyone who opposed them.

On April 9, 1917, Lenin left Zurich on a special train provided by the German government. The Germans calculated—correctly—that if Lenin returned to his native Russia he would cause so much trouble that his country would be forced to stop fighting Germany. That would allow the Germans to concentrate on beating the British and French and to win the war. Half of the plan worked: the storm Lenin created did lead Russia to abandon the war. But the Germans lost anyway. In the end, Lenin did far more than reshuffle the forces in World War I.

His very presence was electrifying. The first speech Lenin gave on his return affected people in exactly the same way as the most extreme Dada event: "it seemed as if all the elemental forces had risen from their lairs and the spirit of universal destruction, which knew no obstacles, no doubts, neither human difficulties nor human calculation" filled the hall. He was not interested in compromise or reform. He wanted to "smash" the "bureaucratic-military machine." By this he meant getting out of the war, but it also implied totally transforming first Russia and then the entire world. The machines Lenin had in mind involved all of human society. And this, too, was like those avant-gardists who thought that their artistic and intellectual breakthroughs heralded a new age. Lenin's Communist revolution seemed to be a perfect partner for the artistic revolution fomented by radicals like Malevich and Lissitzky. For a time it was.

By November 1917, the Bolsheviks had seized power. But they were a tiny minority and realized that, through both force and propaganda, they had to take control of the rest of the nation. Anatoly Lunacharsky, the first Soviet Commissar of Education, understood that art was "a powerful means of infecting those around us with ideas, feelings and moods." That left it to Soviet artists to spread the virus. One artist who took the lead in doing so was Vladimir Tatlin, who exhibited in the 0.10 exhibition.

Under Communism, Malevich worked to teach young artists and to create items of every sort—from teapots to wallpaper—inspired by suprematism. But his art always carried a mystical and abstract quality that fit poorly with the workers'

state. He became increasingly interested in flight, and some of his paintings look like objects seen from an airplane. He even began to study rocketry and to think about satellites. Those paintings resembled space stations, long before such structures were first built. Tatlin, and his fellow constructivists, had their eyes much closer to the ground. Tatlin considered industrial materials, like iron and glass, to be the modern marble and bronze. Though abstract in form, their art was specifically designed to serve the political needs of the new state.

The constructivists made the machine not only the subject of their art but its essence. Metallic, geometrical, stripped of all ornament, constructivist designs predict the look of the CD players, cars, and advertisements that surround us today. Their sculptures looked like scaffolding, their paintings like blueprints; engineers were their favorite artists. The platform Lissitzky designed for Lenin was a brilliant piece of engineering that is as striking today as it was in 1920. Like Lenin's thought, it seems to reduce all of life to clean principles, tight structure, and a place for a charismatic leader. Sentiment and decoration have entirely disappeared. The machine

of history and the art of the machine are perfectly joined.

Constructivists designed thousands of posters in bold colors that spread political messages to the people. Filled with passion for the revolution, and armed with new art styles, new uses of color, and exciting insights into graphic design, they flooded the new nation with their art and their ideas. Railroad trains were covered with posters and slogans. And that was only the start: parades, plays, and movies were all used to spread revolutionary ideas. Art devoted to Communist agitation and propaganda came to be called *agitprop* and led to many real creative breakthroughs.

The plays directed by Vsevolod Meyerhold eliminated all the old theatrical tricks. Sets did not mimic another world, they were constructivist objects in which actors, as well as real soldiers, machines, guns, and newsreels challenged and educated the audience. There were no curtains, no stage-light effects; the actors were not even allowed to act. Instead, they could only move according to a set of "biomechanical" motions devised by Meyerhold. Many constructivists, including such talented women as Alexandra Exter and Ludmilla Popova,

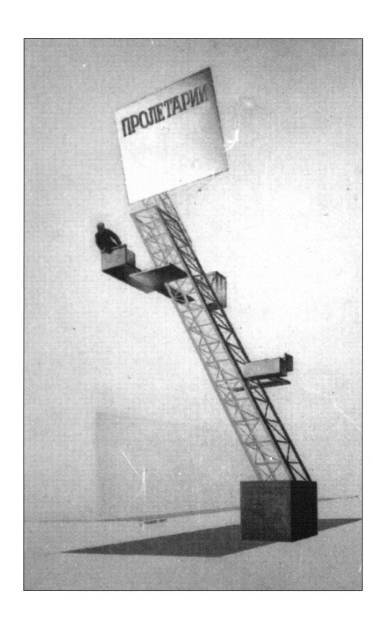

Lissitzky's platform for Lenin is the essence of constructivism: useful, efficient, without any trace of old-style decoration, and as much a political tool as an artistic creation.

(Gouache, India ink, and photomontage on cardboard. 63.8 cm. x 48 cm. and © 1998 Artists Rights Society, NY/VG Bild-Kunst, Bonn.)

Trains like this traveled through Russia advertising the revolution.

found the new agitprop theater a stimulating environment in which to use their mechanical geometric designs.

The presence of many prominent women among the constructivists was a sign of the movement's progressive thought. The Dadaists, cubists, surrealists, futurists, and bohemians, for all of their advanced ideas, were essentially men's clubs in which women were included as wives, lovers, models, or patrons. If that. The futurists' founding manifesto declared proudly that "we will glorify war—the world's only hygiene—militarism, patriotism . . . and scorn for women." The Soviet Union grew more socially conservative in the 1930s, and the question of the place of women in the avant-garde was deferred for another thirty years. As we will see, it

Tatlin's *Monument to the Third International* was intended to be a building larger than the Eiffel Tower that would house an organization devoted to world revolution. Inside the structure were to be rotating offices for different departments. The external girders and the turning inner workings would make this a machine for transforming the world. It was never built.

Alexandra Exter's costumes for the play *Romeo and Juliet* (*below*) were used on her stunning set. At right, the balcony scene resembles something out of an early science fiction film. Though not strictly constructivist, these sets and costumes were typically daring and adventurous.

(Costume renderings courtesy Mrs. Lisa Aronson. This photo of the balcony scene appears in Kostantin Rudnitsky's wonderful book *Russian and Soviet Theater 1905–1932* [New York: Harry N. Abrams, 1988].)

This scene from Fernand Crommelynck's *The Magnanimous Cuckold* shows constructivism in action. The set, built by Ludmilla Popova, is a machine similar to a jungle gym or obstacle course. Like the Wright brothers' early planes, the machine is simple, handmade, and almost flimsy, as well as ultramodern and abstract. The actors, directed by Meyerhold, wear no makeup and move only in his biomechanical motions. (This photo and many other equally fascinating ones appear with no credit lines in Rudnitsky.)

fell to American women to expand artistic rebellion to include feminist issues.

The marriage of avant-garde and Communist revolution extended to every medium. Arseni Avraamov composed a *Symphony of Factory Sirens* that was played in the port city of Baku in 1922. "Played in" understates the case: the people, businesses, and troops of Baku *were* the symphony. The foghorns of navy boats, factory sirens, and army guns combined with mammoth choruses to play revolutionary songs. Nikolai Foregger linked machinery, art, and the people even more closely. His Machine Dances required people to take on the role of motor parts. Their actions were accompanied by a Noise Orchestra made up of such instruments as broken bottles and metal sheets. The "inescapable din" that accompanied some Zurich Dada performances was now the entire repertoire of a Soviet orchestra.

Apparently, the constructivists achieved a revolutionary breakthrough worthy of Soviet Communism. Art was no longer aimed at the wealthy and the refined; now it was directly linked to the needs of the people. While sculptures and symphonies celebrated the materials workers used in their everyday lives, posters, plays, and films taught

them how to live and think in the socialist paradise. The art of the machine was the art of work, freedom, and liberation.

For many creative minds in Russia the decade from the midteens to the midtwenties was a time when anything seemed possible. The zaniest speculations about sound and energy mixed with the most practical work on new machines. Out of this mix came the musical instruments we hear every day. In 1921, the brilliant Russian acoustical engineer Leo Theremin demonstrated to Lenin himself a new instrument he had invented. The theremin is an instrument that has no strings, no keyboard, no mouthpiece. A box containing electrical equipment generates a tone. The musician plays the air that fills the space between an antenna and a curved wire that are attached to the box. As the artist's hands move within the electrical field, the pitch and volume of the tone change. The result can either be recognizable music that mimics other instruments or entirely new and very eerie sounds.

In 1927, Theremin moved to the United States where he sold the manufacturing rights to his instrument to RCA. The theremin found its way into American life: Hollywood composers used it in science fiction films; it was demonstrated on an episode of the *Mickey Mouse Club;* and at least two 1960s rock bands featured its sound. Though Lothar and the Hand People are forgotten by all except lovers of the theremin, the Beach Boys' classic "Good Vibrations" is one of the most popular songs to survive from that era. Theremin's influence was not limited to his instrument. His work directly inspired Robert Moog, the inventor of the synthesizer. We owe all of the synthesized—as well as much of the electronic—music of our time to Theremin.

In the late thirties, though, the Soviet government kidnapped the man they knew to be a genius. Back in his homeland he continued to work on sound transmission by developing bugging devices for the KGB, the secret police. Theremin's life took him from wide-open experiments on the border between scientific brilliance and mystical fantasy to grim production in service to an oppressive state. That was the precise fate of the Soviet avant-garde.

As appealing as the link of worker, engineer, and artist was to many creative people in the Soviet Union, it posed a fundamental problem for the avant-garde. The avant-gardist, Malevich argued,

Clara Rockmore, Theremin's greatest disciple, playing the instrument named after him.

(Toppo, New York. Clara Rockmore was kind enough to lend us this undated photo herself.)

goes out into the wilderness, ignoring conventional beliefs. How could an artist do that when the wilderness was everywhere? Once in power, the Bolsheviks decreed that both money and private property were illegal. At a stroke they destroyed the entire capitalist economy. In practice, though, this also created a flourishing black market that everyone knew about but had to pretend did not exist. The new state was both a far more thorough critic of bourgeois life than any artist and a far bolder inventor of absurdity. An artist might make fun of the money-hungry middle class, but only the Communists could make the price of goods increase one hundred millionfold between 1918 and 1923.

If the avant-garde politicans were creating an avant-garde state, how could the artist rebel? Wouldn't that make him or her a conservative, even a reactionary, not an innovator? But how could artists who rejected all prior rules and standards be confined by the needs, and even worse, the taste, of the masses? It was this problem that destroyed constructivism, suprematism, and the lives of many great Soviet artists.

"Our Business Is Rejoicing"

The Fifth Symphony of Dmitri Shostakovich fits this section.

Leningrad (St. Petersburg), October 21, 1937

The abolition of money was an economic disaster, as were many of the Bolsheviks' efforts to run a vast country as if it were a simple machine. As conditions grew worse, the leadership decided to exert more control over the arts. Art for the people, they decreed with ever greater force, must be art the people could appreciate. Celebrating the machine was fine, but incomprehensible abstractions were not. As in Manet's Paris, there were no independent galleries or museums. And in Russia, there were no independent collectors. An artist's success depended entirely on the government. Only the government could grant secure teaching jobs, set up prominent exhibitions, or commission large-scale works. When a visionary like Malevich lost favor he had few options. Throughout the twenties he had to scramble to hang on to lesser and lesser posts. All along he tried to find a way to retain his mystical suprematist vision while pleasing the state.

Lenin died in 1924. By 1928, Joseph Stalin had defeated his rivals and was poised to set his own policies. He put into effect a ruthless and ruinous plan to eliminate all private farming—by starving the farmers to death. He insisted on transforming his nation, no matter what the cost. The cost was high. Between his enforced famine and the waves of arrests, executions, and sentences to slave-labor

camps in Siberia that he ordered, Stalin was responsible for at least twenty million deaths. He killed three times as many of his own people as Hitler did of Jews and other "subhumans." The aim of all of this terror was not merely unquestioned obedience to his policies, nor even a huge pool of unpaid labor. Stalin had a further goal worthy of the maddest mad scientist. He wanted to turn all of the people of his nation into feelingless zombies. As the musical historian Ian MacDonald has put it, he tried to produce "a nation of human robots programmed to love only the state." This was the horror of "machinishness" beyond all imagining. Soviets were not to imitate machines but to become them.

Stalin and his henchmen did not neglect the arts. As they began their collectivization campaign, they instituted a series of official policies defining exactly what artists could and could not do. Now the penalties for making anti-Soviet art were not merely economic: the wrong style could land an artist in jail, in Siberia, or in a grave. Faced with these rules, Vladimir Mayakovsky, a great experimental poet who once totally embraced the revolution, killed himself. Too many followed his example.

Others, like the painter Marc Chagall, left their homeland for Paris or America, never to return. But most artists were not ready to die and were unwilling or unable to leave.

Great avant-garde creators like Malevich faced a series of impossible choices: they could continue on their own paths, knowing that no one would ever see their work and that both they and their families would suffer horrible punishments. They could give up everything they believed in and paint false pictures of happy workers who loved their tractors. Or they could try to find ways to fool the system, appearing to comply with the new regulations while actually subverting them. The state that was supposed to bring humanity to the next stage of development was forcing its best artists to speak in a kind of coded Dada language of jokes, symbols, and double meanings.

Hounded by critics who called his work "counterrevolutionary sermonizing," Malevich struggled to find a way to remain true to his vision without writing his own death sentence. He turned to the work of Giorgio de Chirico, whose paintings were exhibited at the Cabaret Voltaire. De Chirico's paintings of plazas and abstracted people shimmer

(*top left*) Malevich's pencil sketch of a faceless peasant, *Godmother,* was as abstract as *Black Square* and as realistic as the regime demanded. (7" x 10⅝", drawn around 1927 or 1928. Courtesy Leonard Hutton Galleries.)

(*above*) Does this Malevich pencil sketch, *Peasant Woman in the Field,* suggest that she has been silenced, or that she is of the land and knows its black-and-white truths? (7⅜" x 11", drawn between 1925 and 1927. Courtesy Leonard Hutton Galleries.)

(*bottom left*) Malevich titled this pencil drawing *Silence,* which makes clear that the man has been muzzled by his beard. (8³⁄₁₆" x 9⅜", drawn around 1930. Courtesy Leonard Hutton Galleries.)

with mystery and mysticism. No matter how real the scene, every shadow and window seems symbolic. This style offered Malevich a way both to satisfy and evade the censors. Instructed to paint real people, not abstract forms, he showed colorful peasants—with no faces; proud athletes—that could be suprematist checkerboards; realistic self-portraits of an artist wearing medieval clothing—that could be a costume from *Victory over the Sun*. Though the state prevented him from leaving, and from getting the medical attention he needed, it could not rule his art. Malevich was not the only artist to turn false compliance into a great art form.

Dmitri Shostakovich was a composer who did such a good job of fooling his critics that the true nature of his music was not revealed until after he died. Though he went in and out of favor with the Soviet leadership throughout his life, all along he had been using his work to show his real feelings about them. Perhaps his greatest achievement came at his moment of greatest peril. In 1932 the state adopted a new policy toward the arts called socialist realism. Artists were not only forced to give up abstraction, they were required to show a happy story of the inevitable triumph of Communism. To this day some critics and teachers feel that art ought to contain "positive" messages, especially when it is directed at students. Socialist realism was this view taken to its ultimate extreme. Any of the small truths of real life were erased and replaced by the single large Truth of the government's decrees.

By 1936 this policy was causing real problems for Shostakovich. Stalin himself had written a scathing review of his last work. Seeing that, his friends avoided him. They fully expected that he would soon be shipped off to the slave camps, or worse. The composer wouldn't even allow his Fourth Symphony to be performed. Yet he knew, for certain, what was going on in his country, including the enforced famine in the Ukraine and the artists who could not be silenced. The poet Osip Mandelstam recited to him a poem he dared not write down, a poem that exposed Stalin's monstrosity. Imagine being an artist who knows a horrible truth, knows that revealing it will be suicide, and feels that silence will be a betrayal of his soul. According to Ian MacDonald, in the Fifth Symphony, Shostakovich both saved his own life and registered the horror of Stalin's terror.

The piece was first performed for the public on October 21, 1937. By that time Stalin's campaign of terror had reached such a pitch that almost everyone knew of a close friend or relative killed or imprisoned by the government. Yet, to show the slightest sign of unhappiness was considered a betrayal of the state. To cry in public, even to seem hesitant or confused, was a mark of disloyalty. The Fifth Symphony contains movements that clearly express tragic emotions. Hearing music that allowed them to feel what they were forced to hide every minute of every day, the audience members wept and wept and wept. When it ended, they kept clapping and clapping far into the night. The response was so strong that even Stalin hesitated to attack the composer. But what was the piece actually saying? The last movement is very upbeat, and Shostakovich included musical quotations that implied the piece was a kind of confession of faith. His life was tragic, the score suggested, until he grasped the truth of Communism. Now he was as happy as any good socialist realist. Or was he?

Since his death, Shostakovich's secret thoughts have been published, and we know that he was not. The happy sections of the symphony sound forced,

frantic. "What exultation could there be," his posthumous book asks. "I think it is clear to everyone what happens in the Fifth. The rejoicing is forced, created under threat. . . . It's as if someone were beating you with a stick and saying, 'Your business is rejoicing, your business is rejoicing,' and you rise, shaky, and go marching off, muttering, 'Our business is rejoicing.' " Shostakovich solved his dilemma by creating a great work that meant two absolutely opposite things at the same time.

Great art now could only exist in double meanings, in hidden commentaries that mimicked official policies only to undermine them. This was a very dangerous path because the censors were alert to just such "deviations." Even following their decrees, though, was no guarantee of safety. Sergei Prokofiev was a more compliant composer than was Shostakovich. While one was composing a symphony to express tragedy, the other wrote his *Cantata for the Twentieth Anniversary of the October Revolution*. The cantata was created to fit the spirit and the letter of Stalin's policies, and the words came from the most revered Communist texts. Designed to be performed by the people themselves in huge choirs, the story line began with

Marx and led up to Stalin and his greatness. It was as obvious and submissive as the Fifth Symphony was subtle and defiant. But by the time the piece was finished, people were so scared to perform anything at all that they advised Prokofiev not to release it. The cantata remained hidden until long after he died. When it was finally performed in the sixties, Stalin was so unpopular that the parts about him were omitted. The perfect Communist piece was censored twice, once in fear of Stalin and once out of hatred for him.

The Soviet dream of uniting avant-garde art with radical politics resulted either in death, silence, and masks or pathetic servility to inhuman tyrants. Yet there are twists even to this story. To this day, Prokofiev, composer of such classics as *Peter and the Wolf* and the score for the ballet *Romeo and Juliet,* remains more popular and more accessible than Shostakovich. The rules the Soviets sought to enforce through terror and decree had something in common with the much milder policies of Hollywood studios. Both commissars and media moguls wanted happy art for a mass audience that made people feel good. Such policies only inspired devotees of the avant-garde to be ever more extreme, ever more radical. From the twenties to the forties the avant-garde explored a world that was no longer even real, it was "surreal."

Surrealism

Erik Satie's score for **Parade** *starts off this section. George Antheil was an American composer much favored by the surrealists. His* **Ballet Mécanique** *is a classic of experimental music that caused all the appropriate riots in Paris and New York. The score accompanies a film by Fernand Léger that is an avant-garde masterpiece in its own right. The Joffrey Ballet's reconstruction of* **Parade** *is available on video.*

Paris Between the Wars

Where could art, or even anti-art, go from *Rite of Spring*? The 1917 ballet *Parade* was a kind of all-star answer from the Paris-ian avant-garde. For those who could make out the code, the libretto by the poet Jean Cocteau indicted the audience at Nijinsky's ballet for mistaking the scandal for the art. The score by Erik Satie included parts for typewriters, sirens, airplane propellers, telegraph tickers, and lottery wheels. The sets and costumes by Pablo Picasso turned American skyscrapers—the very image of modernity—into tottering cubist headdresses. And the liner notes by the avant-garde poet Guillaume Apollinaire added a new word to the French language: *surreal.*

Parade explored scandal, noise, cubism, and city life. These were the preoccupations and discoveries of one generation of avant-garde artists. Surrealism was the battle cry of their successors.

Led by André Breton and Louis Aragon, the surrealists based their entire artistic movement on the exploration of the unconscious. They made art

out of the images revealed in dreams. They explored the phrases we speak under hypnosis or while in a trance. They revered the texts we write when we exert no control over the words that tumble down onto the page. Surrealists were like deep-sea divers, plunging into the dark, uncharted depths of the human (or even inhuman) mind. Part psychological exploration and part séance, surrealism seemed to have unique power to make both radically new art and astonishingly free life.

If, right now, you were to write down every thought you have, every image you see, every feeling you experience, every one, no matter how wild, silly, sexual, or violent, right now, let them flow, no control, you would have a surrealist poem. Try it, you never know what you might find. Or you could play one of the surrealist games, such as Exquisite Corpse. One person sets down a line on a page, folds it over, and hands it to the next. When you finally unfold the page the poem you have created together, without conscious control, is your surrealist creation. You can do the same thing with a drawing. The name of the art-game came from the very first poem it produced:

the exquisite
corpse
shall drink
the new
wine

Or you could try Truth or Consequences, the surrealist game in which players have to answer every question they are asked, with no limits. The art patron Marguerite "Peggy" Guggenheim explained that the "object of the game was to dig out people's most intimate sexual feelings and expose them." Most recently, Madonna used this game as the connecting thread of her movie, *Truth or Dare.*

Breton was inspired by Jacques Vaché, a person whose greatest artistic creation was his exquisite disdain for the world. Breton and Vaché would go to the movies together, but not to see the films. Instead, they brought in food and wine and held a picnic, as if nothing else were going on around them. Yet if he liked a play and others didn't, Vaché was known to stand up and threaten the crowd with a gun. When Vaché died of an overdose of opium, Breton was devastated. But he was also impelled to explore his own unconscious.

Breton had already been drawn in that direction by a wartime experience. To please his parents Breton had been studying to be a doctor. During the war, he worked in a psychiatric clinic where he read the works of Sigmund Freud in German. That made him one of the first people in France to know about the psychoanalyst's path-breaking efforts to make sense of dreams and to map the unconscious. When he applied Freud's theories to mentally disturbed soldiers, Breton was astonished. The images they reported were pure poetry, "on a higher plane than would occur to us." Like the rabbit hole in *Alice in Wonderland,* the unconscious beckoned to Breton, daring him to enter its land of unreason, passion, and magic.

During this period, Aragon introduced Breton to an extremely strange book. Written in the 1860s by the Comte de Lautréamont, the *Cantos of Maldoror* is like a piece of the unconscious shipwrecked in the sunlit world. In one section *Maldoror* explored a variety of enigmatic and disturbing endings to the phrase "beautiful as." One of the most evocative was "beautiful as the chance meeting on a dissecting table of a sewing-machine and an umbrella." Like a dream, that phrase can

suggest many different things. In one way, it could be chance nonsense—like Dada. In another, the objects on the table might stand for a man and a woman. An object that is a person points to both Duchamp's playfully erotic readymades and the automatonlike Soviet Machine Dances. Objects, people, and dissection combined in dreamlike images; this was a direct forerunner of surrealism, and of one specific dream.

One night as Breton was about to fall asleep, he had an unusual experience. As he explained years later, "a rather strange phrase . . . came to me." This phrase did not just flit through his mind. It demanded his attention, he heard it out loud. The image his unconscious was sending to him, thrusting at him, was of "a man cut in two by the window." Think of that image, a window bisecting a man. What could you see through it? All of surrealism was an effort to look through that window into the hidden and unpredictable world of "thought . . . in the absence of any control."

The surrealists who gathered around or were influenced by Breton came from many different countries. The painters included the German Max Ernst, the Belgian René Magritte, the one-time

French sailor Yves Tanguy, the Spaniards Joan Miró and Salvador Dali; there was the American photographer Man Ray and another Spaniard, the filmmaker Luis Buñuel. Among writers, one could add the Frenchmen Paul Éluard and Robert Desnos and even perhaps yet another native of Spain, the great poet Federico García Lorca.

Surrealism opened new horizons to many talented artists. In their hands, time and watches melted. Like shamans, they summoned the beast-men that have haunted us since we lived in caves. The most common objects, such as a cup and saucer, became strangely sexual and alive. They played endless tricks with our eyes, leaving us unsure of what was real. Inevitably, though, surrealism produced a whole new class of artistic illusions.

From the first, Breton and the surrealists were fascinated with billboards, movies, and publicity. Part of their genius was in public relations. Soon surrealist imagery found a home in fashion, advertising, and film. Even as artists seemed to make the most radical step away from normal life, they generated styles that were used to make everyday life more appealing and saleable. Like the cubist art that Gimbels used to sell dresses, surrealism became a

This is one of the plates in Max Ernst's collage novel *A Week of Plenty*. It seduces you into thinking it is an old Victorian print, then shows all the feelings and desires that hovered at the edges of that emotionally overheated, overcontrolled world. Ernst's plain style makes the scaly aberrations all the more potent. (© 1998 Artists Rights Society, NY/ ADAGP, Paris.)

fixture of fashion photography. This link of the unconscious and manipulation went beyond fashion. Freud's nephew Edward Bernays moved to America, where he invented modern public relations. Some of the most able exploiters of unconscious yearnings turned out to be demagogues such as Adolf Hitler and filmmakers such as Leni Riefenstahl who supported him. But surrealists were not without resources. In the last years of the twenties Magritte painted a picture that comments on the entire world of images that surrounds us every day. That

(top) **Meret Oppenheim's best-known work was a surrealist triumph that has spawned many interpretations. Her 1936 *Object (Breakfast in Fur)* is one of the few major surrealist works by a woman.** (Courtesy the Museum of Modern Art, New York.)

(bottom) **This 1931 Dali painting is the most famous surrealist image. *The Persistence of Memory* was its title, but the image of melting watches is what everyone remembered. The familiar, rational world runs on measured time. But once we cross the line into dream and memory, time is as slippery as Dali's oozing image.** (9½" x 13". Courtesy the Museum of Modern Art, New York. Given anonymously.)

work is one of the most powerful and important avant-garde paintings ever made.

Magritte painted a pipe, and underneath it added a phrase that translates as "This is not a pipe." We see a pipe, but are told it is not a pipe. What is it, then? It is a painting of a pipe. Even the words that remind us of this are not a caption or a title, they, too, are part of the painting. Things are not what they seem, they are what they are. An image is an image, it is not what it pretends to be. A painting is applied paint, anything else is illusion. What, then, of all the other illusions we agree to believe in, to honor, to respect as if they were real? The actual title of the work makes exactly this point: it is called *The Treason of Images.*

Why is this painting so revolutionary? What are we surrounded by, especially today? Screens, monitors, billboards, ads that claim to tell or sell us something. We willingly enter into their illusions. We agree to be fooled. But Magritte lifts the cover off of the lies. These black marks you are reading right *now* are just ink on paper. If they are anything else it is only because we all agree to that. What if we were no longer fooled at all and took everything for just what it is? What if we could see all of

If this is not a pipe, what is it? René Magritte's 1928–29 *Treason of Images.*
(23¼" x 31⅞". Courtesy Giraudon/Art Resource, NY and © 1998 C. Herscovici, Brussels/Artists Rights Society, NY.)

the embedded codes around us? In a second painting Magritte made exactly that point. Surrealism was a kind of cannon pointed at everything that we agree to pretend is real.

Magritte's painting is so astonishing because its effect only begins when you look at it. The ques-

tions it raises never stop. In *The Treason of Images* Magritte was the boy who points out that the emperor has no clothes, or, better, that we believe that his clothes make him king, when they are just rags. Today, people who experiment with virtual reality and with on-line experiments such as MUDs and MOOs think they are pushing the borders of reality. But Magritte went much further than they ever do. No matter how real a technological illusion is, you can turn it off and return to normal reality. Magritte made us question everything in normal reality. That is a challenge that can never be turned off. Art, though, can grant only so much freedom, so much insight. It has little direct power against tyranny. And, in the late thirties, tyrannies were expanding all over Europe.

As economic conditions worsened throughout the world, and as uncompromising political movements like fascism, Nazism, and Soviet Communism gained strength, artists had four terrible options. They could put their art at the service of dictators. They could dive into their surreal world and blot out all the suffering around them. They could try to bridge the surreal and the all too real.

If we woke up one morning inside of a stage set made to look exactly like the world of the day before, how would we know that it was a set? We'd need a surrealist cannon to blow a hole in the illusion. This is Magritte's 1930 *On the Threshold of Liberty*. (45⅜" x 57⅞". Courtesy Giraudon/Art Resource, NY and © 1998 C. Herscovici, Brussels/Artists Rights Society, NY.)

Or they could leave Europe. These choices split the surrealist movement apart.

In the midtwenties Breton felt ever more anxious to expand the surrealist assault on conventional life. "In the current state of European society," he wrote, "we remain devoted to the principle of any revolutionary action whatsoever." Directly anticipating the battle cries of the sixties, he swore that "we profoundly hope that revolutions, wars, and colonial insurrections will annihilate this Western civilization." Breton found his way to revolution through an unexpected ally—Communism.

In the fall of 1926, Breton read the memoirs of Leon Trotsky. Intelligent, articulate, and passionate, Trotsky was one of Lenin's closest allies. He remained an inspiration to one wing of Communists and socialists even after he lost a power struggle with Stalin in the midtwenties. Though he escaped to Mexico, he lived under constant threat and was eventually assassinated by Stalin's agents. Seeing a fellow revolutionary in Trotsky, Breton decided to marry surrealism and Communism. While this seemed to link the firebrands of the mind and dream with the radicals of the factory and machine, it was as problematic as Malevich's hope of creating totally abstract art for workers. In the midthirties Stalin began to hold staged trials in which people were tortured into making false confessions and then murdered for their "crimes." When Breton heard about them, he protested and abandoned Stalinism, though he remained a Communist. Aragon remained loyal to the Soviet government. This dispute turned the founders of surrealism into bitter enemies.

The crush of political events was even more devastating for other artists. García Lorca, while not active politically, was a homosexual and clearly not the sort of artist favored by the armies of the Spanish fascist Francisco Franco. The poet was killed during the bloody civil war that brought Franco into power. Once the Nazis gained power in Germany, they declared all avant-garde art to be "degenerate." Those artists who could, fled, while others were either silenced or murdered. In Italy the futurists fared better, but only because they put their machine-oriented, promodern, proviolence art at the service of the dictator Benito Mussolini.

In the Soviet Union the Communist promise of liberation created an avant-garde that could only survive in lies. In the rest of Europe, surrealists kept

opening the drawers of the mind and finding the same dark forces of sexuality and violence. Freeing the deepest drives only seemed to make people more susceptible to manipulation by horrific tyrants. European civilization and its herald the avant-garde were at a dead end. Max Ernst's wartime painting *Europe After the Rain* made this terrifyingly clear. Years before he knew of the atomic bomb, the landscape this surrealist envisioned was the scene of nuclear disaster. Seared and corroded wreckage glowed with a kind of radioactive vegetable life. If anyone survived, it was a non-European "primitive." Once again, an avant-garde artist saw all too well: the old routines had failed, but people who stripped off their inhibitions were like atoms pushed out of their orbits. Neither could be drawn back, yet together they would turn the planet into a poisoned cinder, lit by the fires of hell.

Max Ernst's *Europe After the Rain* was painted during the war, from 1940 to 1942.
(21½" x 58⅛". Courtesy Wadsworth Atheneum, Hartford, Connecticut. The Ella Gallup Sumner and Mary Caitlin Sumner Collection Fund and © 1998 Artists Rights Society, NY/ADAGP, Paris.)

Broadway Boogie Woogie

There are many jazz-inspired classical compositions, including Satie's Parade, *Antheil's* Jazz Symphony, *Stravinsky's* Ebony Concerto, *Francis Poulenc's* Rapsodie nègre, *and, the most famous, George Gershwin's* Rhapsody in Blue. *Gershwin specifically sought to express "the young, enthusiastic spirit of American life," and he used both popular and classical forms to do so. In reverse, works such as Duke Ellington's suite* Black, Brown, and Beige *might be called classical-influenced jazz.*

New York in the Forties

Throughout the twentieth century, European avant-garde artists saw America as the very essence of modernity. America was the home of airplanes, of cars and tall buildings, movies and cowboys and Indians; a land where speed, machines, and money ruled. Though *Parade* was seldom performed, it remained important in avant-garde history for what it said about America. One of the main characters was "the American girl," and Picasso's costume turned another, "the New York Manager," into a living skyscraper. America, too, was the home of African Americans, and what Europeans thought of as their music, jazz.

Jazz rhythms, jazz phrasing, jazz syncopations run through the music, dance, literature, and even painting of the European avant-garde. Often, as with Zurich Dada, jazz was a sign of the tribal and the primitive attacking tired Old World culture. Jazz was exciting because it was sexual, violent,

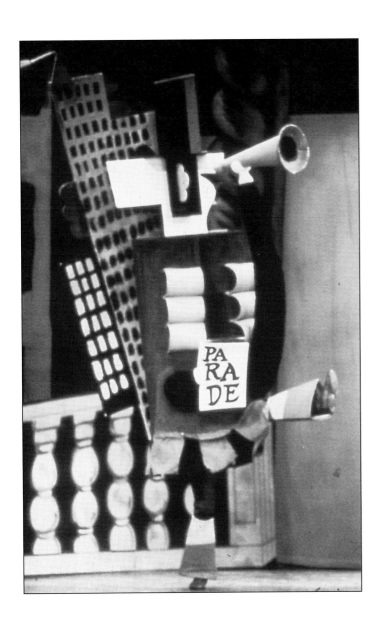

unfamiliar. While this view treats jazz as exhilarating, it also expresses a kind of contempt. Jazz was good because it was bad. The same is true today: the main market for the black anger expressed in rap is among white teenagers.

European artists who were eager to add some jazz spirit to their compositions were much less anxious to visit the land of jazz. Duchamp, who invented readymades in New York, was one of the few exceptions. The New York Dada circle that formed around him was an exciting center in the teens and twenties. But Carl Van Vechten, who later played an important role in the Harlem Renaissance, was a much more typical case. He journeyed to Paris where he joined in the the opening night follies when *Rite of Spring* had its premiere. Like Van Vechten, everyone knew that the real avant-garde could be found only in Paris and satellite cities such as Munich, Milan, Petrograd, Barcelona, and Prague. To European intellectuals, the actual

The New York Manager from the Joffrey Ballet's reconstruction of *Parade*.
(Courtesy Herbert Migdal.)

America seemed to be a hazy Hollywood set or a
materialistic, puritanical backwater, not a home for
the world's most challenging art. World War II
changed all that.

ns worsened in Europe, avant-garde
inds fled to America where they
pectedly receptive audience. By the
nerican collectors and museum cura-

tors knew the avant-garde well. In New York, the
Museum of Modern Art (MoMA) owned the
world's best collection of cubist art. American
artists studied its exhibitions the way sixties rock
fans listened to the latest Bob Dylan or Beatles
albums. The painter William Baziotes made so
many trips to a Picasso retrospective at MoMA that
he felt he "could smell his [Picasso's] armpits and

In the 1930s and 1940s New York's Museum of Modern Art not only housed many important artworks, it helped define what was modern art. In turn, American artists who frequented the museum invented abstract expressionism, the next new school of painting. MoMA's director, Alfred H. Barr Jr., prepared this chart for the cover of an exhibition catalog in 1936; it still hangs in the museum's library. (Courtesy the Museum of Modern Art, New York.)

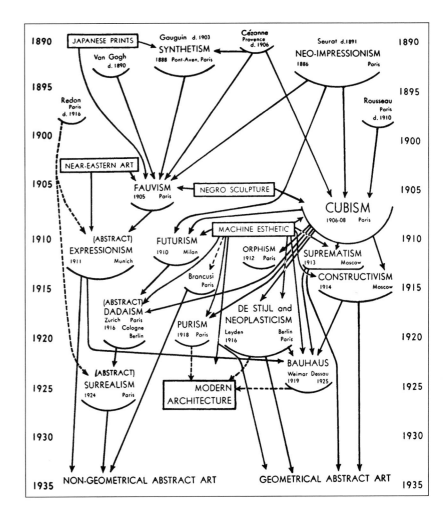

the cigarette smoke on his breath." Arshile Gorky, another important painter of the thirties and forties, was notorious for slavishly imitating each of the latest European movements. Unfortunately, just as he mastered a style, Picasso would adopt a new one. Gorky did not mind. By working through the entire European avant-garde, he eventually created his own significant new art.

The European exiles' influence was not limited to wealthy sponsors, museum patrons, or experimental artists. They also quickly found positions in colleges, where they inspired a new generation of American students. From their bases at the New School for Social Research in New York, Black Mountain College in Asheville, North Carolina, and the University of Southern California, the most advanced European artists began to transform American college life. The ideas they brought played a key role in the college protest movements of the sixties. Still, the European exiles' influence

might have been local and temporary had it not been for changes in America. To see how the American avant-garde developed we can look at two artists, one European and one homegrown.

Piet Mondrian is a perfect example of the bridge between the European and American avant-garde. Mondrian spent the last four years of his life in New York, where he recognized and supported the next generation of American artists. But that was not his most important gift to American art. His art and his adopted city seemed to need each other. Mondrian and New York were waiting to meet. Once they did, both began to dance.

Mondrian was born into a devout Protestant Dutch family. He came of age just as art was changing. One after another, he encountered the avant-garde movements we have discussed. By 1909, he was a theosophist and was using paint to deal with mystical transformations. He foresaw a "path from the body to the spirit" much as Kandinsky and the Russians were doing at about the same time. Two years later, he moved to Paris and became a cubist. But there was something unusual about his cubism.

The dark lines that formed the edges of cubist forms took on new meaning in Mondrian's paint-ings. They did not define cubes, instead they took center stage themselves. Looking at a Mondrian from this period after a Picasso or Braque is like adjusting the focus on a camera that is aimed at a stained-glass window: in one you see clear shapes defined by thin dark borders, in the other you see thick dark borders surrounded by fuzzy shapes. This analogy to stained glass was not accidental, for Mondrian liked to compare himself to medieval church builders. He was creating new art that was as complete, and as inspiring, as the rose windows of Europe's great cathedrals. That meant he had to go beyond abstract shapes. By the twenties he was like a space traveler who passes through a black hole into another region of the universe.

In traditional painting, spaces between objects are used to fool the eye. Even in cubist paintings negative space, or background, surrounds a central object. But what if you invent new kinds of spaces, new juxtapositions of line, color, and white that have never been seen before on canvas? What happens when negative space turns positive? The paintings that Mondrian did in the twenties and thirties took on this issue with a force and brilliance never before seen on canvas. They are the

high-water mark of the European avant-garde's interest in pure form.

To a casual viewer, Mondrian's paintings from this period are the essence of total control. At a distance, they yield absolutely nothing to human error or human feeling. Looking at a reproduction of this art you might expect to be able to reproduce it precisely, pixel by pixel, on a computer screen. Yet on the actual canvas lines often, and quite carefully, do not quite reach the edge. Viewed closely, the strokes of paint, the layering of color, are quite apparent. However cool and precise his forms, the humanity of the painter is never lost.

For all of Mondrian's icy brilliance, he was concerned with linking his art with people's needs. In the teens and twenties mass-produced manufactured goods were becoming more and more common. For some, this was a flood of commercial junk that was drowning out real art. But others saw the new manufacturing capacity as an opportunity. If artists could design the items people used every day, the creators could make a living without depending on wealthy patrons. In turn the masses, whose lives would be filled with items designed by geniuses, would be absorbing true culture all of the time.

Mondrian's response to this challenge came in his involvement in a Dutch movement called *de Stijl* (the style). This was a different form of the effort toward total art we have seen so many times before. Like the Soviet constructivists, these Dutch artists hoped that if buildings, furniture, and household appliances were perfectly designed and coordinated, there would be no need for art, for everything would be art. We would live in an art environment that was totally harmonious and in a society that was equally balanced and composed. Mondrian's own studios reflected this view. He carefully placed colored rectangles on the walls, painted and repainted the floors and walls, and arranged the furnishings into a three-dimensional version of his paintings.

A parallel movement in Germany that stressed the unity of the arts and was concerned with both applied and fine art was called Bauhaus. The name came from a school located first in Weimar and then in Dessau where some of the most important architects and painters of our time taught. Walter Gropius, for a time director of the school, invented the style of rectangular, functional, clean-lined office buildings that surround us to this day. Another lineal descendant of Bauhaus style is the sleek

black look of German coffeemakers. The Bauhaus school, its teachers, and the art they created were all condemned or suppressed by the Nazis.

In the early thirties, inspired by de Stijl's utopian ideas, Mondrian hoped that a better world was about to be born. By the end of the decade he knew better. He fled to London in 1938 and then to New York two years later. How would this ultimately severe painter react to messy, mixed-up, American life? Enthusiastically. Mondrian was a jazz fan. When he came to New York, some of its color, and rhythm, and life seemed to enter his paintings. Now his black lines turned into color stripes. Instead of creating artwork with the frigid beauty of arctic light and prison bars, he began a series of paintings titled *New York* that were warmer and more playful.

Most of Manhattan is laid out in a rectangular grid. Numbered streets run east-west, intersected by avenues that travel north-south. Aided by the then recently invented colored adhesive tape, Mondrian seemed to be exploring all of the life, energy, and pulse that vibrated within that grid. The very last painting he completed is called *Broadway Boogie Woogie,* and it heats up the vibra-

Mondrian at his cold, austere best in his 1920 *Composition C.*

(23¾" x 24". Courtesy the Museum of Modern Art, New York. Acquired through the Lillie P. Bliss Bequest.)

tions still further. Each block and avenue has its hot spots, precisely as you would see them in an infrared photo of the city. These paintings may not be as magnificent as the ones he did in Europe, but

they are more alive. If the Old World yielded cathedrals, the new one offered jazz.

Mondrian's glacial art was not so much melted by the city as it was broken into tinkling cubes. In return, he showed New York how alive, how brimming, and spilling over with color it already was. Every block, every house, every intersection was abuzz with life. Just as he was experimenting with color patches, he recognized the talent of one young artist who could barely contain his spews, rants, and splashes of paint. In 1943, Mondrian saw the work of Jackson Pollock and made sure the art patron Peggy Guggenheim came to appreciate and sponsor it. Mondrian moved from pure abstraction to buzzing life. Pollock plunged into the heart of that vital energy and used it to redefine abstract art. His life was a voyage to the outermost edge where art, magic, and inspiration meet.

New York and Mondrian come alive in his *Broadway Boogie Woogie,* **painted between 1942 and 1943.**

(50" x 50". Courtesy the Museum of Modern Art. Given anonymously.)

Art = Truth

Some of the most experimental twentieth-century composers in America were extreme individualists, in the manner of the nineteenth-century transcendentalist Henry David Thoreau. Charles Ives was an insurance executive who, on his own, developed a style that paralleled some of the Austrian composer Arnold Schoenberg's path-breaking experiments with twelve-tone scales. Ives's **Three Places in New England** *makes fun of small town marching bands and includes the instruction to "count as if practicing the beginning and getting it wrong." Henry Dixon Cowell cowrote the first important biography of Ives, but he was a different kind of experimenter. Some of his works are played by banging on a piano with a fist, and he worked with Theremin to develop a rhythmicon, an ancestor of the rhythm options on modern synthesizers. Cowell's beautiful* **Hymn and Fuging Tunes of 1944,** *though, is based on an early American hymn and is very easy to enjoy.*

The American artists who pored over the canvases at MoMA and were thrilled to meet the European exiles had a problem. They learned from the cubists that the form of contemporary art must be abstract. Yet they also believed the surrealists, who claimed that the true inspiration for new art was the subconscious. The surrealists, though, seemed to find only recognizable figures—no matter how distorted, playful, or monstrous—when they delved into their dreams and painted their fantasies. Like good students with warring teachers, the Americans were puzzled and had to find their own path. They sought a way to be true to the unconscious and to the formal challenge of modern art. This was an appropriate problem for America in the forties and fifties.

American life, you could say, was becoming more and more abstract. Between the government-sponsored programs Franklin D. Roosevelt established to combat the depression of the thirties, the huge expansion of government, industry, and the military during World War II, and the record-breaking boom in building, business, and the media after the war, America was transformed. At the turn of the century 37 percent of Americans

worked on farms. In 1920, for the first time, most Americans lived in cities, and by 1940 only 17 percent were still tied to the soil. In large urban centers, more and more people worked for giant corporations. And after the war there came a new wrinkle. The car and the suburban home became the ideal. Road mileage tripled from 1925 to 1945, and in 1952 the government committed itself to creating a massive interstate highway system. A faceless giant corporation with its headquarters in New York and tentacles throughout the land was not so different from an art movement centered in New York that featured faceless paintings filled with spidery tracings.

After the war, in the fifties, all the power of corporate America was put into creating a calm, unified, and peaceful image of the nation. As television became ever more popular, shows became ever more bland. The suburban family with a happy hard-working dad, a perfectly groomed and always calm stay-at-home mom, two charmingly mischievous children, and a shaggy dog appeared in endless variants in magazines, ads, movies, and TV shows. Even comic books were regulated to make sure they were not too violent or disturbing. While

Senator Joseph McCarthy and other demagogues used fears of Communism to build their careers and to persecute independent thinking, milder leaders such as President Dwight D. Eisenhower stressed that "everybody ought to be happy every day." Artistic rebellion seemed like an echo of a distant, and unsavory, past.

At the same time, though, there were many gaps in this paved-over picture of the land. At home, America was divided by race, by income, by sexual orientation, and by religion. Overseas, America had fought a terrible war against seemingly demonic foes. In order to win, it had used the most destructive weapon in human history—the atomic bomb. Just beneath the surface of abstract corporate America there lurked violence, savagery, hatred, and passion. The challenge for avant-garde artists was to capture both surface and depth. For some, the answer came in myth.

In the late forties New York artists such as Barnett Newman, Hans Hofmann, Ad Reinhardt, Mark Rothko, and Clyfford Still were painting what they called *ideographs*. According to one dictionary, this is "a character or symbol which suggests an object without expressing its name." In our

terms, that is an icon. Today icons are used in software programs; they allow you to get things done by pointing and clicking. On the Web, blue underlining works the same way. It means you can make a link to a related site somewhere else. These painters were trying to create icons that linked to the deepest, oldest, most universal human feelings and experiences. You did not click on them, you experienced them, meditated on them, felt them, and thus felt yourself. Viewers might be disturbed, as if they had dipped underwater, entered a dream, or fallen into a trance. Good. But the viewer was not the only one unsettled by the ideographs.

Where could an artist go to find these profound symbols, these hot buttons to the heart of humanity? He (overwhelmingly these painters were male) could look at "primitive" art, especially works made for and used in rituals. He could study the works of the Swiss psychologist Carl Gustav Jung, who devoted much attention to the enduring power of myth and symbol. Finally, he could venture into himself, into his own private landscape, on a quest to find these shards and embers of our ancestral being.

Titles and themes such as Orpheus descending into the underworld, Ishmael (or Ahab) hunting Moby Dick, or pioneers rolling out across the plains came up again and again in the American painting of the late forties. This was very American—the idea of setting forth, alone, against the unknown. Malevich rejected centuries of Russian and European tradition to go into the wilderness. In America, setting out into the wilderness was the national tradition. The artist was taking on the role of Columbus, of the pilgrim, of the cowboy. The innovative modern dancer and choreographer Martha Graham explored such myths on-stage, often using sets and costumes by the sculptor Isamu Noguchi. But there was another, even older American tradition, and this proved to be more powerful than any of these familiar themes.

Out on the plains, away from the roadways, shunted off to reservations, were Native American healers. "The Indians," Pollock said, "have the true painter's approach." Creating their sand paintings was not an act of art but of life, perhaps of magic. The designs were destroyed after they served their purpose. The art was not a symbol of faith, it could only emerge when it had been made in faith. Perhaps the real art of the American quest would

come not from myths and symbols but from the artist's own fight for truth. In the battle against the limitations of paint and surface, the struggle against doubt, the wrestling with passion, would emerge a work of art that showed every stroke, and plunge, and drip of the fight.

When would it be finished? Only in that perfect moment when the artist sensed it was; when he found a balance point within and without. This was an art of violent expression that required a new and utterly undefinable poise. It was undefinable because no rules of traditional or abstract art could tell the artist where to find it. There were no road maps, no stop signs, and no ways to turn back. If the artist missed the end, overpainted his canvas, he had to live with his own failure. No erasing allowed. But when he got it absolutely right, he built out of himself a work of art that was both the record of a spiritual journey and its end. He didn't describe truth, he lived it.

More than any other artist, the "he" who took this trip was Pollock. He so defined the image of the postwar American artist that he seems more like a character in a novel than a real person. Yet even this fits. Whether he was the perfect artist/spiritual frontiersman, or the perfect public relations picture of one, hardly matters. After all, a big part of being an American hero is selling yourself as one. Think of Davy Crockett, who not only had many exploits on the frontier but won a seat in Congress by boasting about them. William F. Cody (Buffalo Bill) was a real scout and Nebraska legislator whose life was totally transformed after he met a brilliant author of popular fiction. Through his novels, Ned Buntline turned Cody into a wildly popular hero and then cast him in a play about his own life. Buntline's play evolved into Cody's Wild West Show, which brought the image of cowboys and Indians to the world and was recorded on film. Pollock was Buffalo Bill all over again.

Appropriately, Pollock was born in Cody, Wyoming, and grew up in California and Arizona. Throughout his life, and decades before it was popular, he wore boots, not shoes. Among the many jobs his father held was as a surveyor, helping to build the new American roads. Like Mondrian, Pollock studied theosophy, and also like the Dutch genius, he changed his name as he settled into a new phase of his artistic life. His teachers were the leaders of the two dominant schools of American painting.

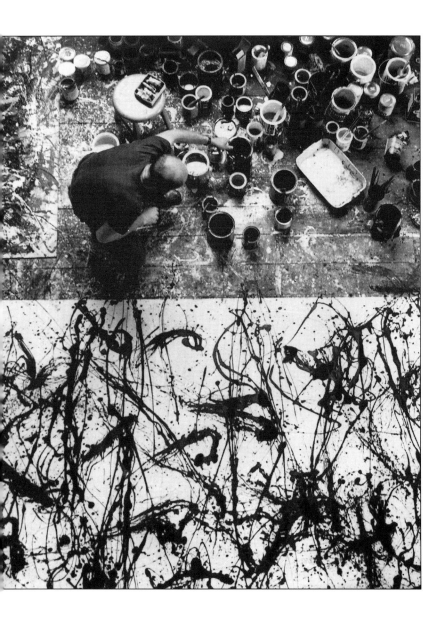

Thomas Hart Benton was the best painter of murals of regional folklore and rural life in the nation. And the Mexican José Clemente Orozco was, along with Diego Rivera, the most visible advocate of a popular art of social protest. From the midthirties to the end of the Federal Arts Project in 1943, Pollock was paid by the government to be an artist. This program served two purposes. It supported artists, and it brought excellent murals to post offices and other public buildings throughout the nation. With his prominent teachers and government support Pollock explored everything that existing American art had to offer, then he went on his way toward his own vision.

Typically, there was a dark side to this odyssey. Like so many other artistic rebels, Pollock was expelled from high school. He had little money, continually doubted himself, and was a severe alcoholic.

This amazing overhead shot of Pollock painting captures both the process and the result of his drip method. The action and the art are linked, and yet almost seem to be black-and-white mirror images of each other.
(Courtesy Rudolph Burckhardt.)

Pollock was so troubled by his failings that, in 1937, he checked himself into a hospital. The following year, he began psychoanalytic treatment with a Jungian analyst in New York. During the period of these sessions he began drawing gnarled nightmare figures whose hellish screams echoed the most extreme self-torture and violence. Yet—and here is the crux of the myth and the art—it was through these battles within himself and the page that he found his great truth.

Pollock sold his first piece to MoMA in 1944. *She-Wolf* was one of those mythic figures that erupt onto canvas. According to the artist it "came into existence because I had to paint it." The following year he married Lee Krasner, herself a talented artist, and moved to Long Island, New York. During the Second World War a term that had taken on a new meaning in the previous war became popular. There were precious few "breakthroughs" in World War I. But thirty years later they were common. Sudden advances that obliterated obstructions were as frequent in medicine and atomic science

Pollock's *Echo (Number 25, 1951)* shows the results of his leap into the painting. His lines seem to depict hair and body parts, or to be merely traces left by bold, spontaneous gestures. The painting keeps shifting: it is pure energy, it is a map of nightmares, it is as random as a doodle, it is as composed as a classical painting.
(Enamel on unprimed canvas. 7' 7⅞" x 7' 2". Courtesy the Museum of Modern Art, New York. Acquired through the Lillie P. Bliss Bequest and the Mr. and Mrs. David Rockefeller Fund.)

as they were on the battlefield. In 1947, Pollock had his breakthrough.

Instead of putting his gigantic canvas on an easel, he spread it out on the floor. That allowed him to "feel nearer, more a part of the painting, since this way I can walk around it, work from the four sides and literally be *in* the painting." Working this way, he could not use a conventional brush. He dripped paint from cans and from housepainters' brushes, every gesture showing on the canvas. Pollock began without knowing where he would end, inventing the final order and form of the work as he went along:

> When I am in the painting, I'm not aware of what I'm doing. It is only after a sort of "get acquainted" period that I see what I have been about. I have no fears about making changes, destroying the image, etc. because the painting has a life of its own. I try to let it come through. It is only when I lose contact with the painting that the result is a mess.

Pollock's paintings were like the tracks of his family, every family, searching across the continent for their new home, their new job, their American dream. And they were more than that. The huge canvases did not sit nicely on a wall, they blotted out everything else. Pollock did not paint the landscapes he saw, he created new vistas as wide as billboards. "I am nature," he thundered, and his pictures seemed to prove him right. They were as new, as encompassing and complete unto themselves, as the world's most powerful nation.

Pollock's best years were the late forties when he created one astonishing drip painting after another. He also kept up with his treatments and managed to stop drinking. But in the fifties he seemed to lose his way again and retraced his steps back toward figures and symbols. By this time, the Cedar Bar on the edge of the Village in New York City served as the center for young artists. Drinking again, Pollock fed his legend with his exploits there: he crushed glasses in his hand, tore the men's room door off of its hinges, and ripped the headlights off cars. With tragic appropriateness, he died in 1956 in a car crash. The final line sailed off the edge of the canvas into alcohol and death.

Pollock's splattered canvases were not the only approach for American painters of his generation. Just the opposite idea appealed to other painters such as Mark Rothko. They tried to continuously remove all ideas, references, and images, until they

found a pure shimmer of sublime color, mood, and feeling. This was an art of ultimate distillation. Rothko's paintings were as large as Pollock's. He, too, sought to encompass the viewer in the world he had created. But this was a world of absolutes, not approximations. Ad Reinhardt painted black squares on black canvases. Rothko filled a chapel with brooding, almost invisible, colors.

In 1941, Henry R. Luce, publisher of the popular magazines *Time* and *Life,* declared that the "American Century" had arrived. He did not see either variety of the new art as part of that optimistic era. Yet, whether painters left no room for background or placed nothing at all in the foreground, they were asserting their dominance over the past, the present, and the future, just as Luce was. The solitary American hero was in charge, whether in war, in peace, or on canvas. Or was he?

Franz Kline's paintings show traces of the gestures that went into making them. But unlike Pollock's massive canvases, they are spare and tight, and often resemble calligraphic posters in an unknown language. This untitled ink on paper piece probably dates from 1960.

(11" x 8½". Courtesy McKee Gallery.)

Cool Is Hot and Hot Is Cool

Bebop pieces that might fit this section include Dizzie Gillespie's "Salt Peanuts," Charlie Parker's "Night in Tunisia," and Thelonious Monk's "Straight No Chaser"; a recording called The Quintet *features Gillespie and Parker together live—it documents what has been called "the greatest jazz concert ever." The documentary* Thelonious Monk: Straight, No Chaser *suits this section.*

America, the Fifties

Painters were not the only artists who were willing to battle alone, and with no rules, for new truth. In the forties a new generation of jazz musicians did something very similar. Trained in the popular dance-oriented big bands of the thirties, these artists were looking for new kinds of challenges. Their jazz was not meant for dancing, nor was it expected to be wildly popular. This was a new kind of jazz that deliberately set out to be avant-garde and that took exactly the same risks as the New York painters. Bebop artists pushed out at the limits of speed and sound toward the edge where trumpet and saxophone sounds cracked and inward toward space and silence.

When fans tried to describe bebop, the fierce new music took over their words. Their descriptions followed the unexpected rhythms, the strange beats, the sudden riffs of the jazz masters. Robert Creeley, a poet who had studied at Black Mountain, wrote this to his teacher Charles Olson:

Chas Parker is gone, very truly, beyond any damn

expectable limits of sd 'musick' and hangs there, just damn well hangs. . . . Always, the edge is, given, is always a doubling in on; the given, a kind of *thing*, to be expected, to be brought round the hands, to have them so shape round it, to *hold*. . . . BLOW / GO / MAN / GO!!

"Go" and "gone" were the right words. Bebop sped like souped-up cars on the superhighways. Jack Kerouac wrote a series of poems after Parker died. He captured what happened when notes were pushed faster than any human had a right to play:

> *"Wail, wop"—Charley burst*
> *His lungs to reach the speed*
> *Of what the speedsters wanted*
> *And what they wanted*
> *Was his Eternal Slowdown.*

Bebop's legacy for the American avant-garde was hyperspeed that rushed toward death but also toward bliss, the "eternal slowdown." Like Parker, all too many of the musicians were heroin addicts and died young. In slang, "gone" was used as an adjective. If it could mean departed, it also suggested ascended, lifted off, or what in the sixties would be called "out of sight." This paradox of falling as far down as drugs and self-destruction could take you while aiming as high as the human spirit could ascend was the keynote of a generation of poets, novelists, and artists.

In 1947, the same year that Pollock painted his first drip painting, Kerouac met Neal Cassady in New York. Kerouac then set off on a cross-country trip that became a model for generations of avant-garde rebels. The following year he gave a name to these exiles in their own land: the beat generation. Taken from heroin addicts' slang, *beat* meant ultimately down, defeated, destroyed. It also, though, implied true, weighty, without any falsehood. And, in 1954, after studying Buddhism, Keroauc realized that it had yet another meaning entirely: beatitude, beatific. If you sank all the way down, you just might fly all the way up. Once you left conventional life behind, you might land anywhere, in hell or in heaven. He published *On the Road,* his novelized account of his journeys with and in search of Cassady, in 1957. *On the Road* was the bible of the beats. It was a kind of road map to the America those outcasts felt and saw and inhabited.

Kerouac proclaimed that "the only people for

me are the mad ones, the ones who are mad to live, mad to talk, mad to be saved, desirous of everything at the same time, the ones who never yawn or say a commonplace thing, but burn, burn, burn like fabulous yellow roman candles." Cassady, called Dean Moriarty in the book, lived his life like a bebop solo. Whether he was stealing cars, driving them as fast as they could go, carrying on simultaneous relationships with two women and one man, or talking nonstop for hours, he never stopped burning. Cassady went in and out of jails and reform schools all his life. Kerouac saw that as "a wild yea-saying overburst of American joy; it was Western, the west wind, an ode from the Plains, something new, long prophesied, long a-coming (he only stole cars for joy rides)." Born in a car as his parents passed through Salt Lake City, he seemed to incarnate the restless new West where there was nowhere left to go, but everyone was going there.

The cast of characters in *On the Road* is a kind of index listing all of the Americans who were ignored or excluded by the fifties ideal of suburban conformity. Divine jazz musicians, Okie families living lives straight out of John Steinbeck's *Grapes of Wrath,* hoboes bumming endlessly from one railroad yard to another, families of Mexican grape pickers with beautiful daughters, addicts, winos, pimps, gamblers, merchant seamen, traveling salesmen and the teenage girls they dallied with in kitchens, crackpot mystics, and African Americans of every type fill the pages. Kerouac yearned to be more like all of them:

> At lilac evening I walked with every muscle aching among the lights of 27th and Welton in the Denver colored section, wishing I were a Negro, feeling that the best the white world had offered was not enough ecstasy for me, not enough life, joy, kicks, darkness, music, not enough night. . . . I wished I were a Denver Mexican, or even a poor overworked Jap, anything but what I was so drearily, a "white man" disillusioned.

Kerouac was recording the times, the places, and moments in which America as a white middle-class world with many hidden and segregated minorities was coming to an end. And yet he was also a tourist in this new land. He never learned how to drive. Even as an adult, whenever he ran out of money his mother bailed him out. For him, becoming "a

Negro" was a fantasy, bumming rides with hoboes was a choice. For the people he observed racism and poverty were conditions of life.

Though Kerouac's novel has many passages that celebrate the romance of being out on the road, it also has a tone of sadness and emptiness. At one point Allen Ginsberg, unimaginatively called Carlo Marx, asks, "What kind of sordid business are you on now? I mean, man, whither goest thou? Whither goest thou, America, in thy shiny car in the night?" This was a double-edged question. Where was average America going in its shiny cars, following its false middle-class dreams? And yet, where, too, were the broke, battered, and restless beats speeding off to in the night? There was something "sordid" in their affairs. Cassady left a trail of wives and children across the land. Kerouac refused to acknowledge his daughter. William Burroughs, called Old Bull Lee in the book, accidentally shot and killed his wife and is routinely described as getting boys drunk in order to seduce them. The beats left two legacies: they undermined conventional America by ignoring its morals and values. This allowed them to appreciate the country's hidden weirdness, its secret passions, and its unexpected holiness. Yet it also left them without any compass of their own, free to abuse themselves and others.

On October 7, 1955, Kerouac "followed the whole gang of howling poets to the reading at the Six Gallery" in San Francisco. The highpoint of the night came when Ginsberg read the first part of his great poem, "Howl." As Kerouac described it to a fellow novelist, "with wine in my hands a gallon jug I'm drinking yelling, 'Go,' Allen is howling his HOWL poem and other crazy poets there, it's mad, it will never end." The effect of that poem has never ended. Writing with both the high anger of an Old Testament prophet and the joy of a William Blake–like mystic Ginsberg got to the dreadful ecstatic heart of the beat experience. Dedicated to Carl Solomon, whom Ginsberg had met in a mental hospital, "Howl" is filled with madness, drugs, and rage. And yet the passion in the piece is not for destruction but for life and for transcendence. It is most directly the voice of Walt Whitman extended one hundred years into a more difficult time.

Like many of Whitman's poems and *On the Road,* "Howl" contains catalogs of ignored and despised Americans who had been mangled by conventional society. Political radicals, drug addicts, and

homosexuals are portrayed with a kind of sacred grace that both acknowledges their suffering and honors their true beauty. Though it is an indictment, it is as much a celebration, a declaration of independence from any confining definition of what it means to be American. Censors quickly made an effort to prosecute Ginsberg for reading the poem, but they failed. And it was published by City Lights, a small press and bookstore in San Francisco that is still quite successful today.

The audience at Ginsberg's reading probably numbered slightly over one hundred. The vast majority of Americans did not know about him or his poem, and most of those who did found Ginsburg and his poetry unpleasant or excessive, if not immoral or illegal. Yet in the small black-bordered City Lights Pocket Poets edition, it spread across the nation and reached a new generation of readers. It took ten years from Kerouac's first trip across the nation until he published *On the Road*. Ten years after Ginsberg read and Kerouac's novel appeared, protest, rebellion, and avant-garde attitudes were becoming as American as apple pie—and brownies laced with hashish.

Woodstock Nation

The rock music of the 1960s is now so familiar it is used to score commercials. That makes it hard to hear afresh. The Beatles' Sergeant Pepper's Lonely Hearts Club Band (1967) probably did more to capture the feeling of its time and to shape the surrounding culture than any other album. Protest music took many forms, from the early and earnest folk singing of Joan Baez and Peter, Paul and Mary, to the jaunty chants of Country Joe and the Fish and the more complex ballads of Buffalo Springfield.

Though critical of "the establishment," this music was designed to be appealing, and it sold well. Selling protest caused problems for some. Artists such as Yoko Ono tried to combine experimental styles with radical messages. She and John Lennon formed the Plastic Ono Band and recorded an album with the same name. But the most enduring protest music came from Poland's Krzystof Penderecki whose Threnody in Memory of the Victims of Hiroshima *(1960) is still terrifying. The 1970 movie* Woodstock *suits this entire chapter.*

Bethel, New York, August 15, 1969

Whether they drove, took buses, or hitched rides to Max Yasgur's farm, the hundreds of thousands of rock fans gathering for the Woodstock Music and Art Fair had to hike the last stretch. Like campers on a late summer adventure, they made their way through the dark woods, along a narrow path, onward, ever onward, toward the music. Running, singing songs, exchanging

rumors—the festival was free, the fence around the grounds was down—the army of young people rushed on. The marchers were a parade of hippie fashion: thin long-haired men, women in halter tops or long peasant dresses, many wearing beads and headbands and tie-dye. Along the path they saw radicalized friends and familiar-looking strangers from around the country, feeling for the first time the power of their numbers. Posters, programs, and tickets promised "three days of peace & music," but the excited fans wanted more than that. As Woodstock Nation, the young people who slogged through the mud, woke up to the music, and skinny-dipped in the Catskills lakes embodied the dream of transforming America.

To this day, whether as nostalgia or satire, Woodstock remains the symbol of the peace-and-love sixties. Breakfast was provided by a West Coast commune, the Hog Farm; their good works were announced by Wavy Gravy, an archetypical laid-back hippie. If enough drugs, rock, sex, and granola could change the children of driven materialistic parents into Zen saints, this was the moment. The posters for the guru Maher Baba with his mantra "Don't worry, be happy," the tribal groupings gath-ered in tepees, geodesic domes, and under the canopy of trees, the anthems of the rock stars announced that a new age was at hand.

In their backpacks the wide-eyed fans carried battered paperbacks that confirmed their sense that they were a generation with a special destiny. Utopian fantasies such as Robert Rimmer's *The Harrad Experiment* and science fiction novels such as Robert Heinlein's *Stranger in a Strange Land,* with their own vision of new, open lifestyles, competed for space with the The Lord of the Rings trilogy of J. R. R. Tolkien. The festival grounds even resembled Middle-earth. Away from the cities everything had to be made, cooked, and set up by hand. Between the rain-drenched colorful clothes and the long hair, people began to look more like medieval hobbits than modern humans. And then there was the feeling in the air. Everyone sensed that a great quest had begun, and that every moment was significant. If outside, elsewhere, was great evil, that was expected in epic times. In these young people lay power. If they looked bedraggled and humble, so did many heroes when their journeys began. And, like mythic heroes, they made their own rules.

Everything that was hidden, illegal, and uncommon in the rest of America was public, condoned, displayed for all to see at Woodstock. To one side of a hand-lettered sign with prices for drugs a cobbler offered handmade sandals, while on the other, a half-dressed hippie family played songs and games well into the night. To some of the people there, as to the media covering the event, the filmmakers and sound engineers who recorded it, and the millions around the world who paid to listen to it or to see it on-screen, this was the triumph of freedom. A generation that would not put up with old lies, hypocrisy, and boredom was demonstrating its alternative vision of how people could live and love. Woodstock was idealistic young America triumphant. It was the theme park of the avant-garde generation.

In 1950, persons between the ages of ten and nineteen were approximately 14.5 percent of the total US population. Ten years later, this rose to 16 percent, and by the end of the decade, to slightly less than 20 percent. By contrast, in 1990 this number slipped to 14 percent, the lowest figure in forty years. The percentage is now rising again and is expected to reach the sixties' level in the next century. When there are so many teenagers that they learn their values from one another, rather than adopting their parents' rules, society shivers. To both the young people and their elders the world seems on the verge of total change. But what is really changing, society or fashion?

As we have seen, the avant-garde and coming of age have always been twins. Since Rimbaud, the avant-garde has also increasingly explored the overlap of art and life. What would happen when a huge cohort of articulate, middle-class, and influential teenagers came of age? What would happen when the dominant lifestyle was that of the avant-garde? This was the amazing challenge of the sixties and early seventies. Just as artists in every medium strove to eliminate any vestige of difference between art and life, life went wild. A day that began with a carnival-like demonstration designed to taunt the police and appeal to the TV cameras might well end with a theater piece in which naked actors screamed at the audience, daring them to cross the line into fury or freedom. Art, life, media, politics, and fashion were all up for grabs.

This had unexpected consequences. Presented with ultimate freedom, it was easy to find one's

own limitations. Seeing every variety of seemingly free hippie meant being surrounded by an endless array of kids who were cooler than you were. And where did they get their ideas of freedom? Woodstock was, as much as anything, a marketing triumph. The hippie ideal was individual expression, "do your thing." Yet the clothing, ideas, drugs, and musical taste of the crowd were nearly uniform. Again and again, the problem of the sixties avant-garde was popularity.

The teenager as consumer was first studied in England in 1959. Just as rock and rebellion grew ever more popular, businesses became ever more sophisticated at marketing to teenagers. Woodstock was the coming into self-awareness of these consumers—a group that would soon graduate first to fancy sound systems, then to expensive cars and

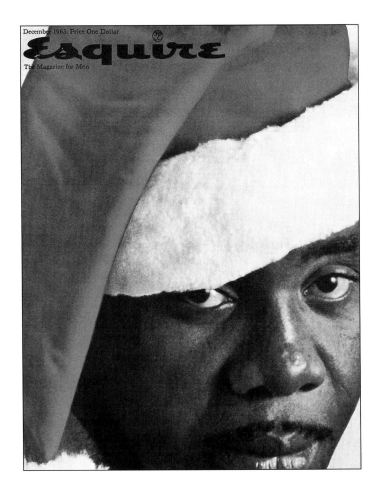

George Lois worked in advertising in the early sixties, just when ads were becoming more "creative" and experimental. In 1962 he was invited to create a cover for *Esquire,* a magazine that was oriented toward men—it was famous for drawings of semi-naked women—but also featured high-quality writing. His first cover, the glowering boxer, Sonny Liston, in a Santa hat, cost the magazine $750,000 in ads. But in time people came to like his smart, funny, and challenging style, and the magazine more than doubled its circulation.
(Courtesy George Lois.)

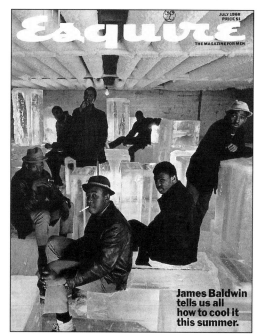

(top left) **Ads that were becoming a kind of pop art, confrontation that was increasingly popular, this was the sixties mix. Here Lois comments on politics and art—the 1968 Democratic convention and the famous writers who covered it—Jean Genet, Terry Southern, Norman Mailer, William Burroughs, John Sack.**

(top right) **Lois on popular radicals—Bob Dylan, Malcolm X, JFK, Fidel Castro.**

(bottom left) **Lois on long hair—the scary hippie heroes are Tiny Tim, Michael J. Pollard, and Arlo Guthrie.**

(bottom right) **Lois on ice-cool black power.**
(All courtesy George Lois.)

homes, and finally to elite schools for their own children. Just like the bohemians of Paris in the 1830s, the hippies were as much passing through a stage on their way to conventional lives as they were challenging convention. Murger and his friends used small magazines to spread their ideas, and hip-pies were inspired by psychedelic-art-filled underground newspapers such as New York's East Village *Other* and the San Francisco *Oracle*. But the hippies were also bound together by a very different, and much more powerful, medium: television. Television changed everything.

"Turn On, Tune In, Drop Out"

Psychedelic rock ranged from the experimental strange—as in the Incredible String Band, the Mothers of Invention, or Captain Beefheart—to overproduced druggy Muzak such as Iron Butterfly. Deciding where innovation ended and self-indulgent commercial junk began was a personal choice. Along that spectrum were sure to be the Lovin' Spoonful, Canned Heat, the Rolling Stones, Cream, the Who, the Grateful Dead, Three Dog Night, Al Kooper's Supersessions, Procol Harum, and the Moody Blues.

The sixties are often associated with drugs, especially LSD. The guru of psychedelic drugs was Timothy Leary, and his most famous phrase invited young people to "turn on, tune in, drop out." With more crackpot messianic zeal than wisdom he claimed that drugs could free a person from both psychological traps and social repression. Leary's call was the ultimate rejection of normal society. But that very phrase sounds quite different when you apply it to the force that, much more than drugs, shaped a generation: television. The all-American injunction to turn on your set, tune in to its message, and drop out from the life around you applies to the becalmed fifties, the radicalized sixties, the exhausted seventies, the couch-potato eighties, and even the net-mad nineties. But no one could see that at the time.

From the fifties to the early sixties, if you asked a likely looking avant-gardist what he or she thought of television, you could be sure of getting a disdainful response. Television, you'd be told, was America's mindless, middle-class, commercial culture at its worst. If the artist you stopped happened to be political, the conversation could get ugly. Many believed that television was doing something far worse than merely numbing adults. It was filling the minds of children with distraction, violence, and yearning for useless products, thus creating a nation of pliant zombies.

According to critics, young people were preoc-

cupied with silly television shows such as the *Mickey Mouse Club.* Like hypnotized elves they rushed to buy coonskin caps, gunslinger's belts, or ridiculous mouse-ear hats just because they saw them on TV. When they could be pried away from the sets, kids read idiotic comics about superheroes—who made them forget the real heroes of the past. Inspired by their reading and viewing, they begged to be taken on vacations to artificial money traps, such as California's Disneyland.

Modern art was safely on the walls of leading museums, but few cared. Modern music was even less popular. As early as 1958, the avant-garde composer John Cage appeared for five consecutive weeks on a televised Italian quiz show, alternating between answering ever more difficult questions about mushrooms—a special interest of his—and making his typically strange music out of a wild collection of instruments including a rubber fish, a bathtub, a pressure cooker, and a blender. He got every question right. Though the painter Larry Rivers had his own stint on another TV game show, the *$64,000 Question,* television did not rush to invite other experimental artists to try their luck. Instead, radio, records, popular books, and TV

seemed to be devoted either to continual huckstering or sappy sentimentalism. American culture had no teeth and no memory. Yet the very power of the media to sweep away the past and create vast armies of eager consumers transformed that culture.

Late at night, on their own cheap radios, kids across America heard music their parents couldn't stand. Rock 'n' roll brought a white audience to the sounds, if not always the original singers, of black rhythm and blues. In the movies, antiheroes such as James Dean and Marlon Brando made teenage defiance popular. *Mad* and *Cracked* led a parade of comic magazines that showed young readers that you shouldn't take anything too seriously, especially your parents. But it was TV that had the most to say to the children of the fifties and sixties.

As the kids who watched Mickey Mouse on TV grew up, they reacted to new images on the screen with the same enthusiasm. By the midsixties old-line TV hosts such as Ed Sullivan were forced to put popular acts on the air, even if they didn't like them. Now, instead of buying Mouseketeer gear young people rushed to imitate the long hair, strange clothes, defiance, and sexuality of singers

such as Elvis Presley and the Beatles. Kids who learned to read by poring over Superman and Batman were introduced to the virtue of weirdness by the X-Men and the Hulk, to self-analysis by Spiderman, and to the idea of mind trips by Dr. Strange. Soon they began creating their own experimental comics in the underground papers. Teenagers who grew up yearning to visit Disneyland still wanted to go to California. But, whether they were drawn to the apparently endless fun of "Surfing USA" near Los Angeles, the political protests in Berkeley, or the experiments in new lifestyles around San Francisco, their California dreams increasingly involved rejecting their parents' values.

For children who grew up in suburban homes where TV rooms and dens were standard features, college was expected to be another stage of the fifties American dream. In 1960, the United States became the first nation ever to have more college students than farmers. By the end of the decade, there were three times as many people in college as there were working the soil. When these students settled into their dorms and classrooms, their parents were in for a surprise. Those avant-garde exiles who escaped to America during World War II had made a lasting impression.

The stalwarts of the European avant-garde—theorists such as Marx, Freud, and Nietzsche, cultural revolutionaries including Baudelaire, Rimbaud, Picasso, and Breton, even Lenin and other political radicals—were discussed in college courses throughout the land. Paperback editions of their works, or posters of their art, were available on every college campus. For the first time ever a nationwide generation of young people was growing up inspired by the ideas and deeds of avant-garde heroes. In "Howl," Ginsberg lamented the loss of his generation. Now, millions were reading his poem and recognizing every one of his references from their undergraduate readers.

This was a potent and volatile combination: a generation obsessed with TV that was eagerly reading and admiring the radicals of the past. Once ignited by the television news, the mix turned explosive. Starting with the coverage of the civil rights struggle in the South, TV news broadcast images into the home that made politics and injustice ever more important to young viewers. As both the fighting in Vietnam and the antiwar protests

grew more heated, no one could escape choosing sides. Opponents of the war, who were themselves part of the TV generation, made good use of the media. They timed their protests to appear on the six o'clock news, when all America would be watching. In the global village, a horrific war far away was every family's living-room argument.

All of the forces seemed to line up: to be young was to be sexually free, intellectually liberated, passionate about rock 'n' roll, and against the war. To be old was to be repressed, conservative, threatened by new music, and for the war. Music, liberation, new art, and radical politics were all one, and very popular. This was a moment no nineteenth-century Parisian bohemian could have imagined, though it came close to sparking a new revolt in Paris in 1968. In some very American way, the most radical ideas of the most extreme thinkers became a nationwide fad. Images of Ernesto "Che" Guevara, the Argentinian-Cuban revolutionary, competed for space in college dorms with pictures of Jimi Hendrix and posters for the Broadway musical *Hair*. Long hair itself, ever a sign of avant-garde status, was the standard look of the well-appointed undergraduate—and high school student if he or she could get away

with it. Support for what was seen as radical art was as universal as those unshorn locks, and as superficial.

Avant-gardism had become a style. Some artists and political militants tried to retain their edge by pushing the extremes of their work ever further out. But when extremism itself became chic, it became harder and harder to separate true radicalism from the fad of the moment. The avant-garde was no longer a marginal critique, it was the battle cry of a generation. It was not a set of beliefs, it was a date on a birth certificate.

When an actor in the Performance Group's *Dionysus in Sixty-Nine* or the Living Theater's *Paradise Now* chose a member of the audience and did his best to make love with her, that act spelled ultimate freedom and radically liberating art to a lot of young people. It seemed tired, exploitative, and shallow to most of their elders (and later to many feminists). There was no way to bridge this gap. Event after event was an explosion into the unknown for some, and a descent into the all too predictable for others. "Never trust anyone over thirty," a phrase from an early sixties protest in Berkeley, California, came to define a seemingly

permanent split between the mindsets of the young and the old.

For many, the sixties was about choices and solidarity: you got it or you didn't. In 1964, led by the author Ken Kesey and the ex-beat Neal Cassady, and powered by pitchers of LSD, the Merry Pranksters drove across the country in a bus named Further. Unlike the broke, hitchhiking beats they filmed everything and enjoyed the best of sound systems. After their journey, accompanied by the Grateful Dead, they held "acid-tests" in which people were induced to take the powerful drug. While on the road their motto was, "Either you are on the bus or off the bus." The black nationalists had their own test phrase, "Either you are part of the problem or part of the solution." When art is life, and both preach radical change, there is no middle ground. But this left serious artists with the same problem as their Soviet forbears: When all the world is avant-garde, what is avant-garde?

Two Walks in the Park

The best accompaniment to this section is Jimi Hendrix's Electric Ladyland *and Bob Dylan albums from the period, especially* Blond on Blond *and* Highway 61 Revisited. *For John Cage, try* Fontana Mix. *Perhaps the best way to "hear" Cage is to perform 4'33", which is described below. The 1973 documentary* Jimi Hendrix *includes some scenes in Washington Square Park.*

New York and Japan, the Sixties and Today

If, today, wearing headphones and listening to Jimi Hendrix CDs, you were to visit New York City's Washington Square Park you could make a pilgrimage to one of the most important sites in Hendrix's life. Walking north under the arch where John Sloan and his friends declared the Village an independent nation, you would soon come to Eighth Street. Heading due west from Fifth to Sixth Avenue, on the south side of the street you would encounter a small bronze plaque at number 52. In distinctively sixties lowercase type it announces that you have reached a recording studio called Electric Lady.

You cannot enter the doors, but musicians say that inside you'll still find the brown shag rug Jimi selected and the varnished collage of magazine images made in his day. With his music soaring, screaming, crying in your ear, you could experience the sixties that was recorded, sold, televised: the sixties that "psychedelicized" millions. If you headed out of the park in the opposite direction, walking downtown past the Judson Memorial

Church where choreographers such as Twyla Tharp and Merce Cunningham reinvented modern dance, you could cover equally hallowed ground listening to Dylan recordings and visiting the places where he lived, sang, and composed. Dylan's music was inspired by Rimbaud and Kerouac and sent millions off to read those avant-garde classics. This, too, was radical art that set out to change your life.

But if you were to start in the exact same place in the park, without headphones, you could find a very different sixties. You could listen to all the snatches of music being played around you: the guitarists, the boom boxes, the a-cappella singers; you could pay equal attention to the murmur of couples on the grass, the patter of vendors selling hotdogs and ices, the skid of skateboarders and in-

"Walkaround Time," a dance piece by John Cage's close friend Merce Cunningham, was a kind of avant-garde all-star gala. On opening night, Marcel Duchamp himself appeared at the curtain call. He stands at the center, to his left is the choreographer. (Courtesy Cunningham Dance Foundation, photo by Oscar Bailey.)

line skaters hurtling across concrete, the routines of performers trying to scare up crowds. Then you could walk down Eighth Street treating police sirens, car horns, and appeals for handouts as a kind of music. If you took that walk, judging nothing you heard, felt, or saw as more important than anything else, you would be in John Cage's sixties. His was a music of chance, one in which art leads you to see that life is so much bigger than you are.

Cage's most famous, and most revolutionary, composition premiered in 1952, long before the sixties. But it is disturbing even today. At Black Mountain he saw paintings by Robert Rauschenberg that were entirely white. The only images they showed were the shadows cast by people looking at them. At a concert hall in Woodstock, New York, Cage explored a similar idea in music. He instructed the musician David Tudor to walk up to a piano and sit in front of it for exactly as long as the piece's title suggested: four minutes and thirty-three seconds. According to the art critic Calvin Tomkins, the "silence" of the piece was filled with many kinds of sounds, including the wind in the nearby trees, rain on the roof, and the muttering and shuffling of the audience. "I would like to think," Cage wrote, "that the sounds people hear in a concert could make them more aware of the sounds they hear in the street, or out in the country or anywhere they may be."

Which experience would be more radical, more avant-garde? Would it be the one that conjured visions of sex, drugs, and rock 'n' roll, of riots at the Democratic Convention in Chicago in 1968, of war protests throughout the land, of bread-baking communes? That music reached greatness in the version of the "Star-Spangled Banner" that Hendrix created at Woodstock. By playing a beautiful note-perfect version of the national anthem, while also tearing it apart with feedback that sounded like the screams of planes diving through the Vietnam skies, or the howls of a nation driven mad by assassinations and bad trips, Hendrix simultaneously soared—searching for America's ideals—and shrieked, wailing over its tragic failings. Or would it be the one that featured silence, the spaces between the sounds we take for granted? Cage fought furiously against any meaning for art, any purpose except for what he called "purposeless games." One is easy and fun, the other hard and elusive. One is available to anyone who can get to the music, the other requires a kind

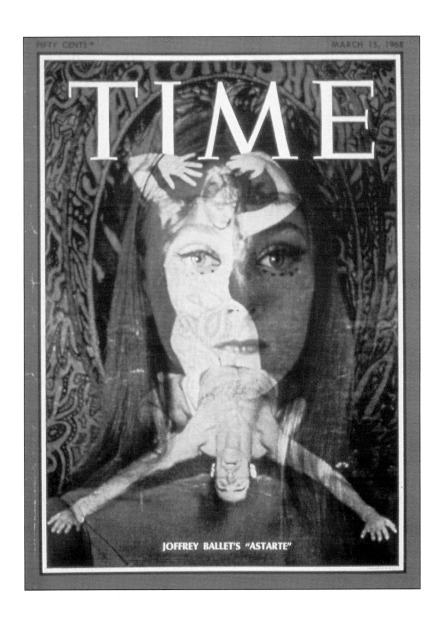

FIFTY CENTS* MARCH 15, 1968

TIME

JOFFREY BALLET'S "ASTARTE"

of patience, curiosity, and attention few of us can muster.

Which is more avant-garde, taking to the barricades to war against the machine—just like everyone else—or being one of those eccentric individuals who would join Cage in his odd games? Which is newer, creating a wall of sound that is a sonic billboard for a generation or undermining every sound, and every slogan, by listening to silence?

There is no right answer to this question. By any calculus of immediate impact or long-term effect, Hendrix and Dylan win. They were directly responsible for one of the greatest periods of cultural upheaval in this country's recent history. Their

The Joffrey's *Astarte* was so popular it made the cover of *Time* magazine. Confrontation, sexuality, audience-as-participant, and artists-as-tribe were all part of this piece.
(Courtesy Herbert Migdal.)

music spoke to the young people who gathered at Woodstock, ended the Vietnam War, and reshaped American life. To this day Cage remains marginal, difficult, and controversial. Few young people, then or now, have even heard of him. Yet he, too, was attuned to the real changes that were taking place around him.

Cage plunged into chance in a way that went far beyond the explorations of the Dadaists and surrealists. They used games such as Exquisite Corpse to get in touch with richer levels of feeling. Cage wanted to get past the self entirely. In one piece, played late one night, his assistants created sound by turning twelve radios on and off, adjusting the tuning and volume as they went along. Static and silence were exactly as important as any sound. At that time, few radio stations broadcast after midnight, so the audience heard little but white noise. If you pointed a receiver at the sky to pick up whatever sound filters to us from the stars you achieve something quite similar. This was the music of chance, of the universe around us, not music that used chance to reveal more about ourselves.

Cage's interest in new kinds of music, and new ways of hearing, led him to anticipate much of the music of our time. As early as 1939 he created *Imaginary Landscape I,* which was one of the first live electronic recordings. In the fifties, he was one of the few Americans to follow the French in their explorations of the use of tape sampling. *Musique concrète,* as this style of avant-garde music was called, was the direct ancestor of the digital sampling that is so common today.

A student of Asian cultures and philosophies, Cage was especially drawn to Zen Buddhism. In turn, when he visited Japan in 1962 a Japanese art patron sponsored a religious ceremony to bless his efforts and the entire avant-garde. This was a perfect act. Instead of being a radical activity undertaken by a few oddballs in Europe or America, the avant-garde was becoming a bond linking advanced, creative minds around the world. Today, when art, ideas, technologies, and fashions flow freely from continent to continent, we live in an environment Cage sensed was on its way. Though Cage's pieces are still hard to listen to as music, they are the works of a prophet. Some critics now think his life was its own kind of prophecy.

Cage's sexual orientation remained a private matter during his lifetime. Yet, his quiet homosexu-

ality stands in direct contrast to the hypermacho of the abstract expressionists and the groupie harems of the rock stars. In later years, sexual choices—gay or straight, public or private, supportive or sado-masochistic—became the subject of much avant-garde art. Such topics were nothing like Cage's totally abstract art. But he and his circle helped break the pattern of the avant-garde, which was to feature white male artists whose heterosexual con-quests were the subject of their art as well as their legend.

Hendrix and the rock stars used TV and popu-lar recordings to bring new ideas and alternative lifestyles to the public, Cage used silence and pri-vate choices to undermine the world we take for granted. He was like Magritte's cannon, now aimed at both psychedelic posters and the straight world. But these were not the only two options for the avant-garde in the sixties. Some artists tried to do both, to be in the public and to undermine it at the same time. For them, calling art a form of fashion was not a criticism, it was just a fact.

Plastic

The Velvet Underground's self-titled first album, which featured the singer Nico, was dark East Coast rock at its best. It sold few copies, but made punk possible. The Doors, the Jefferson Airplane, the Byrds, the Beach Boys, and Big Brother and the Holding Company were vastly more popular West Coast alternatives. The 1996 movie I Shot Andy Warhol *works well here.*

In 1966, a handful of artists returned to New York's 69th Regiment Armory, site of the 1913 scandal. Now, in an event called Nine Evenings, the historic hall was filled with the newest of the new avant-garde. Robert Rauschenberg, the man who had inspired Cage's *4'33"*, was responsible for the most attention-getting experiment. While the audience sat in the dark, a tennis match took place. The players' motions were amplified by contact microphones and their gestures triggered lights. This was art that relied on technology and led to a partnership between scientists from Bell Labs and avant-garde artists that lasted into the seventies.

Nine Evenings was nothing like its illustrious predecessor. It inspired neither high praise nor great controversy. The creative blending of radical art and new machines did not take off until the personal-computer revolution of the eighties. But Rauschenberg was on to something. If there was going to be an artistic revolution, it had to resemble the rest of life and yet be totally different.

Art and electronically amplified sports had a lot in common. Rauschenberg's experiment took after the Happenings that had been initiated by Cage's disciple Allan Kaprow. Happenings were mixed-media Dada-like public events in which the audience was as much participant as observer. As in the Cabaret Voltaire, poetry, film, dance, and anything else, clothed or naked, took place in a space. Whatever happened, then, was the event. Art and life—televised, deodorized, commercialized life—were identical. The person who best understood this was Andy Warhol.

Warhol was a graphic designer who worked in advertising. His job was to make clothes appealing, which is about as middle class and anti-avant-garde

as you can get. For much of his life he lived with his mother and had no discernible personal life. And yet he came to a realization that is probably the most important single thought in the history of the avant-garde. It is so powerful that it may have destroyed the idea of the avant-garde forever.

Throughout its history the avant-garde has been posed against bourgeois society. Radical art has carried the attitude of the outsider criticizing the absurdity and materialism—the emptiness—of middle-class life and popular art. Warhol realized that in an age that glorified television, advertisement, and market research the avant-garde did not have to be against mass culture. Mass culture already was avant-garde.

"Thin is in" was a popular sixties phrase referring to anorexic models such as Twiggy. But it also suggested something else Twiggy's name implied: surface ruled. A silly name, a dress made out of paper, plastic in all of its garish colors and precast forms, were thin, disposable, and therefore all the more profound. Thin was deep. And all depth seemed thin. In a civilization that was made entirely out of publicity, this moment's avant-garde art could only be style, attitude, and plastic. Life was too fast, too mobile, too

far beyond all the old rules to pay any attention to "serious" art.

Plastic has two meanings. In one sense it is any of a group of artificial substances that can be molded into shapes and thus can replace more expensive crafted products. But that very malleability refers to another meaning of the word: plastic means capable of being shaped. Warhol called the light-and-sound show he staged for the Velvet Underground, his rock group, The Exploding Plastic Inevitable. Plastic was exploding everywhere, taking over everything. It was inevitable. But it could also be exploded; you could turn away from society's cast, bend yourself into new and more dangerous shapes. One of the most significant rock groups in Czechoslovakia under Communism was the Plastic People of the Universe. Their arrest led directly to Charter 77, the most important protest by the artists and intellectuals who eventually replaced the Communist government. Their name was like Warhol's stage show. In one way it suggested that the universe was full of plastic people and that this human band would stand against them. But it also implied that these plastic people on-stage might know their way

around things. The Plastic People of the Universe might even be able to squeeze through the tiny gaps in the steel monolith of Communist rule.

In a plastic world, the avant-garde would have to be plastic, too. It would have to be thin, rapidly and infinitely changeable, able to imitate everything else in the world. Thus, to be avant-garde and to be of the straight world overlapped.

In the first years of the sixties Warhol exhibited a series of images that showed how this worked. He and his assistants made nearly exact copies of Campbell's soup cans and Brillo boxes, transferring images directly from photos to silk-screen webs. Duchamp's readymades were objects that he selected and signed. They were funny and provocative; they

Comparing Andy Warhol's 1965 silkscreen *Cow Wallpaper* to Magritte's *On the Threshold of Liberty* shows how the American transformed the avant-garde. If we are trapped by images, he seems to say, let's enjoy it; let's even enjoy how artificial everything is. Image is all. (36⅛" x 24". Courtesy the Museum of Modern Art, New York. Philip Johnson Fund and © 1998 Andy Warhol Foundation for the Visual Arts/ARS, NY.)

were art because it took an artist to see them as art. Warhol's images were what anyone could see on supermarket shelves; they were art because there was nothing else worth seeing.

Warhol was not implying that Brillo boxes were beautiful or well made. This was no de Stijl or Bauhaus link of art and design. Nor was he subtly criticizing America for being such a commercial society that advertising drove out real art. Instead he, oddly like Cage, was saying that what is, is. The way to have avant-garde art is not to stand against society but to mirror it.

To this day, automakers deliberately make cars that do not last very long. Hollywood creates stars by giving actors made-up names and publicizing their affairs. Politicians run negative campaign ads that consist of attacks on their opponents for running negative campaign ads. Warhol called his studio the Factory and gave his ever-changing cast of sometimes transsexual and famously promiscuous actresses names like Viva, Ultra Violet, and Ingrid Superstar that imitated Hollywood and made fun of it. "In the future," Warhol so perfectly predicted, "everyone will be famous for fifteen minutes." Now that we can all have our own Web pages or

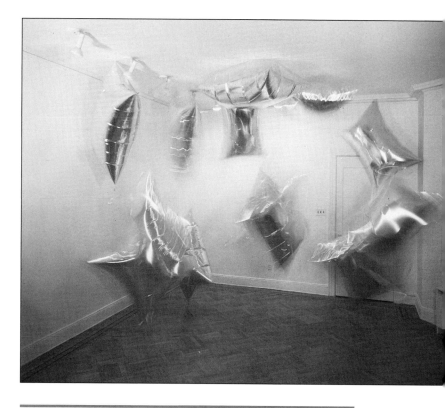

Warhol's 1966 creation *Clouds* is as plastic, as light as art, as heavy as air.
(Helium-filled Mylar. Courtesy Leo Castelli Gallery and © 1998 Andy Warhol Foundation for the Visual Arts/ARS, NY.)

zines we can all be simultaneously famous, though it is not clear that anyone cares.

Warhol was not the only artist to explore this

Warhol's *Marilyn Diptych* turns a movie star into an image of a star, highlighting both her power and her fragility.

(Silkscreen ink on synthetic polymer. Two panels, 82" x 57" each. Courtesy Leo Castelli Gallery and © 1998 Andy Warhol Foundation for the Visual Arts/ARS, NY.)

overlap of high art and commercial culture. Pop artists including Roy Lichtenstein, who turned images from comic books into huge canvases; Claes Oldenburg, who made gigantic soft sculptures in the shape of everything from hamburgers to lipstick dispensers; and Jasper Johns, who bronzed and painted two beer cans, brought the message to every gallery, magazine, and museum. As pop itself became a dominant style, fashions and TV shows imitated the pop imitations of fashions and TV shows. The avant-garde was becoming the play of media images about media images, both earnestly commercial and restlessly playful. This only made sense to a generation that grew up with TV.

In one way, the avant-garde had triumphed. Its radical politics were popular, especially among young people. Whether as rock albums or pop-art posters, avant-garde art seemed to be everywhere. Yet this very success carried the seeds of disaster. After the sixties, it became increasingly difficult to be shocked by anything. If the most radical art was identical to commercial television, both everything and nothing were radical. How could you create a piece that would cause an artistic scandal? Faced with almost any kind of new art the jaded audience

Like all of his sculptures, Claes Oldenburg's giant floppy version of *Two Cheeseburgers, with Everything (Dual Hamburgers)* **is good humored, well crafted, and thought provoking.**
(7" x 14¾" x 8⅝". Burlap soaked in plaster, painted with enamel. Courtesy the Museum of Modern Art, New York.)

could just say, "Well, that's an artist being avant-garde." For a time, it seemed that only Cage—who worked hard at it—could still disturb anyone with

George Lois saw where Warhol left the avant-garde, even though his own magazine covers played on the same border between advertising and art as did Warhol's soup art shown at left.

(*Above:* Courtesy George Lois. *Left:* © 1998 Andy Warhol Foundation for the Visual Arts/ARS, NY.)

his art. "Whenever I've found that what I'm doing has become pleasing," he asserted defiantly, "even to one person, I have redoubled my efforts to find the next step." But in a post-avant-garde world, what could that step be?

In the seventies, the political landscape began to shift. If protesting the Vietnam War made being radical popular, both the war itself and its ending undermined the entire idea of an avant-garde. From the first the avant-garde was a military image. But in Vietnam the whole idea of advance troops lost meaning. An outpost that was at the front one day was lost the next and recaptured in a week. The enemy was everywhere and nowhere. The very idea of a breakthrough seemed dated, irrelevant. And then America lost the war. Victories of any sort—be they military, political, or artistic—were hard to believe in. No matter how dark the visions of a Baudelaire, a Rimbaud, a Ginsberg, they offered a kind of hope. To the few who could appreciate them, these visions presented the possibility of a more enlightened life. No longer. The avant-garde itself was exhausted. When protest music no longer came with exciting demonstrations, when acid-rock concerts no longer carried the hope of ecstatic visions or uninhibited sex, when too many singers and fans started to burn out or die young, the rock revolution began to seem as dated as all of the ancient ideas it challenged and overthrew. President Richard Nixon's resignation in 1974 was a triumph not for new ideas but for cynical disbelief in anything at all.

In the sixties, you might say, the avant-garde made the devil's bargain. It grasped for popularity, and, by holding huge rock festivals and identifying with commercial culture, declared total victory. Except for a few experimenters like Cage, it gave up its position as a difficult opposition in exchange for the hope of transforming the world. When all world-changing schemes began to seem false, silly, or misguided; when all the warnings about the potential costs of "free" sex and drugs began to come true in disease and death, the avant-garde's fifteen minutes were up.

No Future

David Bowie's **Changes** *is an important precursor to punk, as is the Ramones album,* **The Ramones.** *The Sex Pistols'* **Never Mind the Bollocks Here's the Sex Pistols,** *the Clash's first album,* **The Clash,** *and Elvis Costello's* **My Aim Is True** *are key early punk statements. Even the simple, stripped-down titles show the contrast between this style and the pretension of psychedelic albums like the Stones'* **Their Satanic Majesty's Request** *or Blood Sweat and Tears'* **Child Is Father to the Man.**

New York and London, The Seventies

A good place to find the hip and the ambitious in the late sixties or early seventies was near the corner of Seventeenth Street and Park Avenue South in New York City. Max's Kansas City, which was at number 213, was a restaurant that featured steak and lobster, and set out little bowls of dried chick peas on each table. But it was not the food that drew the black T-shirt crowd. Of an evening you were likely to see any of the Factory's stars in full display. Spectacular transvestites such as Holly Woodlawn; Joe Delessandro and other hunks; or any of the female superstars might well be there, holding court. Standing outside on the streets, craning to get a look, were young artists including the singer Patti Smith and her roommate at the nearby Chelsea Hotel, the photographer Robert Mapplethorpe.

Even as some of the Warhol crowd moved on, there were shows upstairs. There you could hear groups such as the New York Dolls who took the Velvets' dark passions and pushed them further into cross-gender experimentation. David Johansen and other male singers were made up like female mod-

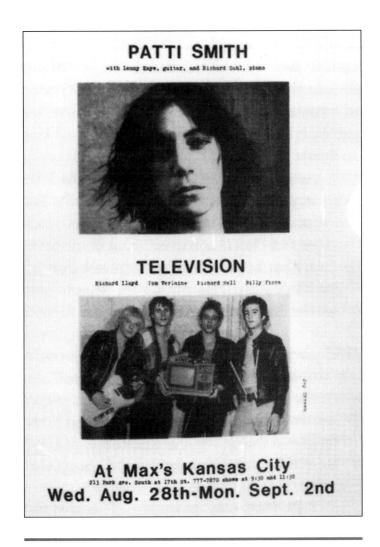

PATTI SMITH
with Lenny Kaye, guitar, and Richard Sohl, piano

TELEVISION
Richard Lloyd Tom Verlaine Richard Hell Billy Ficca

At Max's Kansas City
213 Park Ave. South at 17th St. 777-7870 shows at 9:30 and 11:30
Wed. Aug. 28th-Mon. Sept. 2nd

Patti Smith went from standing outside of Max's to performing there.

els. Their sexual ambiguity suggested an openness to anything, a complete decadence, not any single preference. One visitor who was particularly impressed was the British fashion designer Malcolm McLaren.

In America, rock had evolved out of rhythm and blues. Its roots were in African American music and that of other outsiders including hillbillies and folksingers. Rock was powerful because it was on the edge of the forbidden. It brought the voice of the ignored into every teenager's room. In Britain, though, the sharpest lines were between classes (and regions). The splits in the nation were not as much about race as about money, family, and education. Upstairs at Max's, McLaren heard something that sounded like the poverty and desolation of England in the 1970s.

By combining the grating sound and demolished look of the bands at Max's with his astute sense of sexually dangerous fashion and his sympathy for French radical theories, McLaren invented a future for tired old rock. Through the Sex Pistols, he gave cynicism, exhaustion, and nihilism a voice and a look. Because he created the band to sell fashions, it—and punk in general—was intensely

commercial in its hatred of commerce. It was truly self-destructive, violent, and contemptuous of all meaning. And that was also what it had to sell.

In 1975 a couple of American teenagers from Connecticut created a magazine called *Punk*; this gave the new music, and attitude, a name. Punk was the perfect music to fill the days after the death of the avant-garde. Managers and groups took their names from heroes of the old struggles, such as Rimbaud and Verlaine. One important group in Cleveland changed its name from the Electric Eels to Pere Ubu, which looked back to Alfred Jarry's turn-of-the-century play *Ubu roi*. Unlike the sixties' homages to the past, though, punk came at a time of deprivation.

While hippies could hope to find communes, free love, and the Aquarian age at the end of their journeys, the teenagers of the seventies had no such illusions. In 1975, unemployment in England

The first issue of *Punk* featured Lou Reed, the man who made the bridge from the Warhol-era Velvet Underground to the music the magazine named. (Courtesy John Holmstrom.)

reached its highest levels since the Second World War. The previous year, the Irish Republican Army or IRA—a group fighting to expel the English from Northern Ireland—had launched a bombing campaign in England. There was no safety anymore, either at work or on the streets. Slogans started to appear on London walls that looked back to the old avant-garde rebellions and ahead to a bleak future: "Dada is everywhere," ran one, "SAME THING DAY AFTER DAY—TUBE [subway]—WORK—DINER [sic]—WORK—TUBE—ARMCHAIR—TUBE—WORK—HOW MUCH MORE CAN YOU TAKE—ONE IN FIVE CRACKS UP" declared another. Avant-garde poetry spread like an irresistible sign of gloom over every wall and train station. "Words," announced yet one more graffito, "do not mean *anything* today."

The British government did offer extensive welfare benefits and allowed squatters to live in the buildings they illegally occupied. Yet this only ensured that many people would live in a permanent state of deprivation and frustration. The young and the poor were being warehoused, not helped. And, economists made clear, even that was not going to last much longer: neither Britain nor America could afford it. Both Margaret Thatcher and Ronald Reagan were swept into office on promises of ending all such government assistance. What could come after squatting, welfare, and graffiti? Only homelessness, despair, and punk.

Punk fans announced their hatred of all hope by wearing swastikas. World War II was the defining moment for those who experienced it. Even for sixties radicals it represented a contrast to Vietnam: a struggle against real evil, not an endless and meaningless quagmire. Wearing a swastika was not—as it was then for some Hell's Angels and would later be for some skinheads—necessarily a sign of agreeing with Hitler's murderous racism. Rather it showed that the wearer rejected everything that was sacred to anyone else. "You are so proud of having beaten the Nazis," the emblem said, "what is your victory to me? I lose in your world. I am forgotten and abandoned. All I have is fashion."

Random images, self-destruction, and senseless violence seemed to be the only things left from the tie-dye and Day-Glo sixties. For sensitive teenagers in England and America, the world had a postapocalyptic feel. It was as if, after the total explosion of all radical causes, a gray empty land was being coated

by a drizzle of old phrases and names that no longer had any meaning. This fallout, this radioactive ash of failed avant-garde dreams, offered none of the old optimism. Typically, punk musicians such as the Clash and the Sex Pistols wrote slogans from the Paris revolt of 1968 on their T-shirts, with little thought of what they meant. Yet, perversely, even this ultimate alienation gave punk real force and power, and thus its own kind of hope.

Nineteen seventy-seven was the twenty-fifth year of Elizabeth II's reign as queen of England. A summer of celebrations was planned, all sure to draw tourists eager to enjoy the pomp and ceremony. On July 6, Jubilee night, a boat named the *Queen Elizabeth* traveled up the Thames sporting a banner that read "Queen Elizabeth Welcomes the Sex Pistols." As the boat neared the houses of Parliament, the band began to play "Anarchy in the UK." But the real challenge came from an even more daring song, "God Save the Queen." Its refrain of "no future" spat in the face of the national celebration. Rhyming "God Save the Queen" with "the fascist regime" that night was like simultaneously burning the flag and giving "The Star-Spangled Banner" X-rated lyrics in the

The Sex Pistols tell everyone what England means to them as they ride on the *Queen Elizabeth* during Jubilee weekend.
(Photo by Dennis Morris.)

middle of America's bicentennial celebration. While many older people were furious, the song's terrifying lyrics sounded as revolutionary and true to young people as had Stravinsky's *Rite* in 1913 or

Hendrix's Woodstock set in 1969. The single sold 150,000 copies in its first five days and another 50,000 over Jubilee weekend. The industry journals, though, refused to list it on the charts of best-selling recordings. They chose to leave the number two space blank rather than mention the controversial song.

In dark clubs, where razor-thin people with spiked hair and safety pins through their lips and cheeks danced wildly to the deafening wails of singers who spat at them and screamed about anarchy, teenagers found a safety in danger. Though they might be assaulted by the level of sound, or by glasses or punches randomly thrown by angry performers, they were in a world of their own, protected from the colder, more total violence of the rest of society. The seemingly infinite power of extreme art to take any experience and make it a ritual, a celebration, had been proved once again.

But had it really? Soon skinheads actually were punks and punks dressed as skinheads. Rock groups enacted antigay attitudes even as they cross-dressed. A star such as Sid Vicious could truly be both childishly innocent and psychopathically violent. McLaren both attacked capitalism and signed the Sex Pistols to an unscrupulous contract. As an experience punk offered moments of real brilliance. But as a critique of society, it was doomed to dissolve into its feuding parts. When, in September 1978, Vicious killed his wife in the Chelsea Hotel, and then, in February 1979, committed suicide with a heroin overdose, punk suffered one kind of demise. In 1996, when John Lydon (known as Johnny Rotten in his Sex Pistol days) signed a deal to make advertising jingles, it experienced another. If even the death of the avant-garde could yield its own avant-garde art, it could only be as self-destructive, contradictory, commercial, and anticommercial as all of its proud predecessors. If "no future" was a great lyric, it was also a home truth.

"When Racism & Sexism Are No Longer Fashionable What Will Your Art Collection Be Worth?"

Philip Glass and Steve Reich are leading minimalist composers; try Glass's Glassworks *and Reich's* Music of Mallet Instruments, Voices, and Organ. *Terry Riley is a bridge from their work to New Age music; his* In C *is his most famous composition. Female singers including Tracy Chapman, K. D. Lang, and Sinead O'Conner explore some of the same political and personal issues as the feminist painters and performance artists. The 1996 film* Basquiat *is appropriate here.*

Where could painting, sculpture, theater, and writing go in the seventies? The nihilism of punk was an option only for teenagers. Avant-garde artists still wanted to challenge the old, explore the new, and push for new ways to envision society. But, like the high-decibel punk bands, they could not believe even in the old ways of being a challenger. For many, the whole idea of the avant-garde began to seem extremely suspect. How radical had any of the movements been if they had been dominated by white heterosexual males? How much of a threat had they ever posed if their works now decorated the world's toniest museums, most expensive homes, and fanciest office buildings? Wasn't even the idea of a sole artist who stood heroically for his own truth and was adored by beautiful sexually available women just one more male fantasy? What had this entire heritage of artistic revolt to say to women? To people of color? To gays and lesbians? To people outside of the Western world? How different were the avant-garde aims of radically changing the world from the imperial ambitions of Western colonialists or multinational corporations?

Faced with these kinds of questions, artists turned in essentially two different directions. Some tried to invent new kinds of art that, by their nature, would not fit into the world of museums,

galleries, and collectors. These sites, the artists believed, instantly transformed even the most uncompromising creations into commodities. By limiting art to absolute essentials, creating art that only lasted as long as it was performed, or making art that questioned the making of art, artists sought to escape from this trap. Others claimed that by exploring their own identities as outsiders to the old male-dominated system they could create an inherently avant-garde art. Being female, or African American, or gay made these artists a challenge to a world that did not want to see them or think of them as creative. In the days of *Roots* and "coming out," identity, not form, became the heart of being avant-garde.

In 1963, Cage staged a piece of Satie's that required nine other pianists to perform it. *Vexations* was a short piece that had to be repeated 840 times. This took eighteen hours, yet many of the listeners found it fascinating. That piece looked ahead to a whole new branch of music.

While Cage and the rock stars had each been exploring their visions of sixties avant-garde music, something very different was going on at the col-leges. In the music departments many professors and their top students were still working out Schoenberg's strict views of composition. Typically the music they created was difficult, dissonant, and unpopular. Two composers who had gone through that academic training rejected it. Philip Glass and Steve Reich began their own experiments with minimal changes similar to Satie's piece. Though their work was, at first, performed for small, sophisticated audiences, it soon became popular.

The minimalist musicians did not mind this fame. They were not trying to challenge people in the old avant-garde confrontational fashion. They did not seek to create a scandal. Instead they were getting people to listen in new ways. At the same time, they were linking Western music with different modes of music from other cultures. In the drone instruments of Indian classical music, in the gamelan orchestras of Indonesia, in the elaborate arabesques of Islamic art they found parallels to their new music. Glass collaborated with other avant-garde artists including the performer Laurie Anderson, the designer Robert Wilson, and the choreographer Laura Dean in vast new operas such as *Einstein on the Beach* and *Satyagraha* (the life of

Mahatma Gandhi). This kind of minimalism was much like the fashions being made popular by Calvin Klein in the seventies: cool, crafted, stylish, young. If you did not like it, you could call it avant-garde as ready-to-wear. If you did, it was a kind of new humility, as composers tired of their academic isolation, reached out to the public, and opened their ears to the rest of the world.

Minimalist painters and sculptors were less eager to accommodate their audiences. Richard Serra, for example, placed a huge curved metal arc across a plaza in front of a Manhattan office building. *Tilted Arc* dominated the space, but was not at all decorative. Workers had to walk around it but saw nothing more than the slowly rusting metal. To Serra and his supporters the challenge and irritation it created were part of the piece's value. To many of the workers it was a useless eyesore. Eventually they sued and had it removed. Works that made viewers uncomfortable, and that did not fit old definitions of art, were one possible path for the avant-garde. But if the goal was to undermine those categories, why even make objects that resembled art?

When Duchamp exhibited his readymades he signed them with a funny name. What if one were to sign a blank wall in a museum or even to remove the wall so that the back office and the gallery space were joined? Rather than being a neutral place in which art could be shown, the museum or gallery became the very subject of the artistic confrontation. Art that explores these kinds of questions is called conceptual; it examines concepts of what art is. What, then, if you were to make art that could only be seen, or could only exist, in a specific place? You could film or photograph what had happened there, far away from the critics and collectors, but the actual art, by its nature, could never fit within the walls of a museum. When Christo wrapped eleven islands in Biscayne Bay, or the German parliament building, with cloth, he was creating art that had to be where it was. The art only existed because of where it took place.

We are accustomed to thinking of photographs as records; that is why we believe that Christo actually did complete his projects. As artists came to rely on such documentation, they seemed to be reinventing their own trap. What is the big difference between having a painting on a wall for sale and having a photograph of an event on the same

Vito Acconci's *Soap and Eyes* includes elaborate instructions for how the event took place. This shows how a photo of a performance piece becomes a piece of art.
(Super 8 film. Courtesy Barbara Gladstone Gallery.)

wall also awaiting buyers? One answer was to undermine the photographs. By inventing characters and situations in her staged shots, Cindy Sherman made photos that made fun of photos.

Conceptual art is like having an instant frame that you can put around anything, which then forces you to see that thing as art. Look at these words, this sentence. If you copied it, framed it, put it on a wall, it would be words about art shown as art: a conceptual triumph. Duchamp behaved as if his mind were a camera that could turn anything into art. Conceptual artists go a few steps further, even treating thoughts or feelings as potential art and then raising all the problems about art that critics have been debating for over a hundred years. Conceptual art is like having a framed mirror titled *Art* that reflects back images of everything it faces—thus anything qualifies as potential art. But the mirror has a caption under it that says, "Frames make

fake art"—so anything the mirror reflects is disqualified. Everything and nothing are art at the same time, just because we see them that way.

Because it tries so hard to reject old ideas about art, conceptual art breeds theories about theory. To some this was quite liberating. To others it was like medieval scholastics debating about how many angels could dance on the head of a pin. Moreover, as the arguments became more complex, and the creations harder to understand, this kind of art was all the more certain to remain a sophisticated style aimed at elite, highly educated connoisseurs. Art meant to overthrow the museum and gallery system seemed designed solely to appeal to the same curators and collectors. However beautifully paradoxical this was, some were unwilling to stand for it.

Here's a good avant-garde question: Why have there been no female Picassos? In the seventies, some feminists claimed that this was a false issue. History was filled with great anonymous art made by women. They had spun the yarn, sewed the clothes, quilted the blankets, stirred the pots, and told the stories that raised untold generations of self-important males. Other scholars agreed that there had been few female artistic pioneers but

argued that this absence only exposed the restrictions in societies that had forbidden women to study, leave their homes, or pursue careers as artists. In turn, art historians took new looks at painters such as Mary Cassatt, Georgia O'Keeffe, and Frida Kahlo. Instead of being minor footnotes in histories of male achievement, these were great artists whose unique creations deserved double recognition: as fine art and as explorations of women's roles.

Advocates of women in the arts debated these positions, but all agreed that it was time for the gender imbalance in the arts to come to an end. The Guerrilla Girls, who are still active today, covered New York City with posters protesting male-dominated exhibitions. One of these, from 1989, supplied the title of this section. Judy Chicago celebrated great women of the past in art projects that she thought of as essentially female in all aspects of their design.

African Americans had figured in avant-garde history through jazz, as beat poets, and as the subjects of European art. In the eighties, Jean-Michel Basquiat changed that. For a time, he worked with Warhol, but his style was all his own. Basquiat's paintings brought graffiti, and the new sensibility of

hip-hop, onto gallery walls. Unlike bleak London punk, Basquiat's art was full of color and the sprawl and energy of New York's gay, multiracial, downtown club scene.

If being an outsider gave an artist a special point of view, then maybe art should be just being. Maybe art was not something framed, mounted, held up for view—like a model on a runway or a pinup in a sex magazine. Artists who rejected the old forms of art and artists who questioned the outlooks of the old artists both began to explore the body. While punks stuck pins in their faces, other artists began scarring, cutting, and doing violence to themselves. As an art event, Chris Burden grazed his own head with a bullet, then created a piece in which he kicked himself down a flight of stairs.

This focus on the body led in many directions: for one it had much in common with the interest in sadomasochism that the Velvets had brought into rock. At just this time practices such as bondage and whipping were becoming more popular in some parts of the gay community. When Mapplethorpe took extraordinarily sharp and disturbing photographs of these practices he was both document-

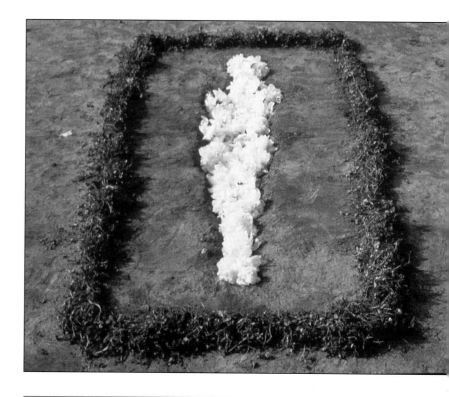

Ana Mendieta made her own body, in its apparent grave, the subject of her art.
(Photograph documenting earth-body work with earth, grass, and flowers. Oaxaca, Mexico. Courtesy Galerie Lelong.)

ing what he saw around him and asserting that these formerly secret and suppressed activities were the very stuff of art. Since many of the men in the

photographs were African American, he was claiming space in art not only for the gay underworld but for the black male. This was doubly unpopular. Some African Americans found his images disturbing and voyeuristic. And then the conservative right got wind of the photos.

In 1989, when Senator Jesse Helms sought to cut back government expenditures for the arts, he used Mapplethorpe's photos as prime examples of deviant work that did not deserve support. This led to angry confrontations and demonstrations that were reminiscent of all the old avant-garde clashes. Apparently, the relativism of the sixties had not triumphed; there was a clear battle line between advanced art and bourgeois society. But on closer look, the Helms-Mapplethorpe controversy only showed how much had changed.

The line the senator wanted to draw between art and deviance was just one of many such demarcations that different groups were puzzling about all over the country. The most liberal colleges that were notorious for their radical rhetoric and communal life in the sixties now debated speech codes and dating rules. The most radical feminists who had been eloquent about female sexual expression now concentrated their fire on images that demeaned women. The most militant African Americans who had objected to all-white art shows now picketed museums that exhibited African American art they found degrading. In 1913, the Armory Show and *Rite of Spring* were shocking because they so directly challenged dominant beliefs. At the end of the eighties there was no dominant belief, only a series of firefights as each group, with its own values and views of art, sought to shape public expression according to its own beliefs. Each sector of society, each group of artists, seemed to be its own avant-garde. Everyone was advanced and yet there was no center to react against. The avant-garde attack had become a menu of avant-garde options.

While the black-leather zipper-strewn regalia in Mapplethorpe's pictures was the very latest fashion, body art also looked back to the past and away from the sophisticated cities. Body piercing, and wearing many rings and clips, linked the most modern art and fashion with the rituals of so-called "primitive" peoples whose ceremonies often involved physical pain and tattooing. Practices that once might have been described only in anthro-

pology texts were performed on stages or seen on city streets and fashion shoots. The world of Rimbaud's delirium was now downtown USA. In another form, body art also appealed to those feminists who thought that the ongoing cycle of changes in women's bodies gave them access to a special kind of truth. Instead of emphasizing torture and erotic fetishes, these artists looked to exclusively female experiences such as childbirth as perfect forms of creation.

The AIDS epidemic, which was named in 1981, added a new spin to body art. The vast devastation that AIDS brought to the artistic community made some feel that the body and its processes were the only subject worthy of attention. In 1994, Bill T. Jones, an HIV-positive choreographer whose lover had died of AIDS, staged a dance called *Still/Here* in which a number of the performers were known to be infected with the virus that causes AIDS.

Still/Here brought together all of the troubling issues that body art raises. If your art is a declaration of who you are—"Here I am, I have a serious illness"—is it still art? How does that differ from politics? How does it differ from a charity appeal in which sick children are shown in a film clip? Can

A scene from Bill T. Jones's controversial dance piece *Still/Here*.
(Courtesy Bill T. Jones/Arnie Zane Dance Company, photo by Johan Elbers.)

a critic, or a member of the audience, judge it as art without considering the suffering of the individual? Isn't that a form of emotional blackmail? Yet, if the most fundamental truth of an artist's life is a

struggle with a deadly illness, or the deaths of friends and lovers from that illness, hasn't the whole message of the avant-garde been to make that tragedy his art? From Rimbaud, to Jarry, to Duchamp, to Breton, to Pollock, to Kerouac, to Hendrix, haven't we seen, over and over again, the artist who makes his life his art and his art his life?

Body art that actually is, as well as describes, the effects of a deadly disease is a perfect emblem of the death of the avant-garde. In the 1400s, a century after the height of the epidemic of bubonic plague, artists painted pictures of the dance of death, showing the sick being led to their graves by dancing skeletons. Apparently the avant-garde hope of changing the world had ended in a new dance of death, this time performed on-stage by living skeletons.

Nothing but Net

You, the reader, are certain to know more about hip-hop, grunge, and postpunk than this author does. Better yet, you have the chance to create the art that goes on beyond these styles. Individually and collectively, the musical accompaniment to this last section is up to you. As a reader, choose whatever you like. As a generation, you may well invent a style of your own. And, it is this very mix-and-match freedom of choice that characterizes the current avant-garde.

Everywhere, Now

Mimimalist art, conceptual art, body art, art with any of the many liberationist agendas, tends to be serious. Each is an effort to salvage the idea of the avant-garde with a new approach, a new program. To some other artists, though, this very idea is dated. We live in a new technological age. Now, we can click from channel to channel, icon to icon, across continents and time zones, in an instant. Maybe the new avant-garde is one that celebrates this freedom, this ability to dip into all cultures, all times, all places, and see each of them as part of our world. If the avant-garde is now a menu, so is just about everything else on our digital screens.

This postmodern sensibility assumes that the old avant-garde idea is over. There is no way to step outside of society, art, culture, and technology, see the future, and confront the numb fools around us with our visions. The present is too sticky. Any effort to step ahead is, just as it is made, immediately transformed into one more art event, one more Web site, one more image in a clip file. The

very effort to be new is old. Creating new music by sampling, sampling, sampling until a single note is plucked from one song, a beat from another, is not an effort to change the world but to swim in all of its possibilities.

Just as artists began to revel in these media games, the spread of computer technology, and most recently of the net, made it possible for ever more people to be in touch. If there is to be a new avant-garde, perhaps it will be found there, as all of you experiment with the links you can make with one another.

The word *net* is a very interesting choice for a system of computer links, as is the name World Wide Web. When we use them casually, we think of the opportunities they provide for communication. But a net, or a web, is also a trap. Are the connections we are making a kind of cocoon, an electronic chrysalis from which we will emerge as better people? Or are they a mummy wrap in which we are entombing ourselves? Are we distracting ourselves with our endless E-mail and losing sight of our real human concerns? Or are we weaving the new fibers that link us each to each as global citizens?

In the forties, Pollock's drip paintings resembled the traces of every family's postwar searches for America. Today they look like a web seen from within. Perhaps now, instead of hoping to find some new truth on the road of life, we can only enjoy the buzz and crackle as we send images, words, and sounds back and forth across the media sources that track every instant of our lives. The media may no longer transmit experiences, it may constitute them. The avant-garde may not bring intimations of the future but rather ever more elaborate sets of mirrors, as we watch ourselves watching ourselves across endless media platforms.

As generations of artists grow up using linked technologies, they may find within them previously unimaginable challenges and opportunities. If the avant-garde first arose in a time when machines and industry transformed rural life, perhaps a new kind of far-seeing art will emerge as information technology eclipses a society built on cars and factories.

Whether there is a new avant-garde, on the net or off, or whether the very concept is too dated to be of any value, is largely up to you. For, as we have said throughout, the avant-garde is a product of being young. It is your concerns, and how you prefer to express them, that will define the future of

Back | Forward | Home | Edit | Reload | Images | Print | Find | Stop

Go To: http://www.databass.com/friederike/the_compound/disaster.html

What's New? | What's Cool? | Destinations | Net Search | People | Software

THE TERMINAL: DISASTER

The only solution is to take part in a common disaster, one that will annihilate me and what I desire. Otherwise I will remain at the compound indefinitely, cycling through the same image repertoire from **the beginning**...

| escape | disaster | **the compound** | **the beginning** |

This is the homepage from Friederike Paetzold's prizewinning Website, The Compound [at http://www.databass.com/Friederike/The__compound/]. A painter and professional Website designer, she has created a piece of fine art that comments on the Web. While there are many interesting places to explore in The Compound, and the sights and images shimmer like surreal dreams and memories, it is a trap. The Web leads to new places, yet imprisons us in an illusion of freedom. (Courtesy Friederike Paetzold.)

the avant-garde. This is all the more true now, because so much of the historical avant-garde has already been absorbed into the rest of our lives.

In 1996, Reebok introduced a new line of sneakers: the Avant-Guards. These use sixties art designs to make for a new basketball look. In our

post-avant-garde age we will see crossovers like this all the time, as sports, art, advertising, culture, politics, speech, technology, and daily life all blur together. The final achievement of the avant-garde's 170-year struggle might well be a state of mind that allows us to explore all of the meanings of cross-media free play all of the time.

For nearly a century, businesses have used avant-garde images to sell products just as avant-garde artists have borrowed some of their public relations strategies from advertising agencies. Perhaps in the digital world this distinction will collapse altogether as the most advanced art and most effective ads instantly steal from, critique, and emulate each other. That is not so far-fetched. Today, trend spotters film young people in clubs to pick out the best look for their products. The most radical is instantly the most commercial, and no less radical for that fact. The avant-garde has either totally triumphed or totally lost, and none of us can quite tell the difference.

Surely there will continue to be artists who are a step more advanced than the rest. Of course there will be seers who understand just that much more about the past, the present, and the future than their peers. Undoubtedly there will be visionaries whose disturbing dreams carry truths everyone else tries to deny. But what form will these creations, prophecies, and visions take? Will they confront us, as the avant-garde has tried so hard to do? Or will they hypnotize, tease, or beguile us? We will always have newness. Will that take the form of an avant-garde? As Jimi Hendrix would say, that remains to be experienced.

Avant-garde movements are often defined as much by the age of their members as by their beliefs. All those born around the same year tend to reject the styles they grew up with, and to favor similar innovations. This list of biographical dates by chapter makes that clear, as long as you squint on the cross-references—such as Bob Dylan in the chapter on Rimbaud.

CHAPTER 1

Armstrong, Louis (1900–1971)

Davies, Arthur B. (1862–1928)

Duchamp, Marcel (1887–1968)

Gogh, Vincent van (1853–1890)

Joplin, Scott (1868–1917)

Luhan, Mabel Dodge (1879–1962)

Matisse, Henri (1869–1954)

Picabia, Francis (1876–1953)

Picasso, Pablo (1881–1973)

Shinn, Everett (1876–1953)

Sloan, John (1871–1951)

Stieglitz, Alfred (1864–1946)

CHAPTER 2

Nijinsky, Vaslav (1890–1950)

Stravinsky, Igor (1882–1971)

CHAPTER 3

Alkan, Charles Valentin (1813–1888)

Baudelaire, Charles (1821–1867)

Berlioz, Hector (1803–1869)

Braque, Georges (1882–1963)

Cézanne, Paul (1839–1906)

Courbet, Gustave (1819–1877)

Debussy, Claude (1862–1918)

Degas, Edgar (1834–1917)

de Nerval, Gérard (1808–1855)

Duparc, Henri (1848–1933)

Hugo, Victor (1802–1885)
Manet, Edouard (1832–1883)
Monet, Claude (1840–1926)
Murger, Henry (1822–1861)
Ravel, Maurice (1875–1937)
Renoir, Auguste (1841–1919)

CHAPTER 4
Dylan, Bob (1941–)
Jarry, Alfred (1873–1907)
Rimbaud, Arthur (1854–1891)
Toulouse-Lautrec, Henri de (1864–1901)
Verlaine, Paul (1844–1896)
Wagner, Richard (1813–1883)

CHAPTER 5
Arp, Hans (1887–1966)
Ball, Hugo (1886–1927)
Chirico, Giorgio de (1888–1978)
Huelsenbeck, Richard (1892–1974)
Kandinsky, Wassily (1866–1944)
Satie, Erik (1866–1925)
Stoppard, Tom (1937–)
Tzara, Tristan (1896–1963)
Varèse, Edgard (1883–1965)

CHAPTER 6
Benois, Alexander (1870–1960)
Kruchenykh, Alexei (1886–1968)
Lissitzky, El (Lazar) (1890–1941)
Malevich, Kazimir (1878–1935)
Marinetti, Filippo (1876–1944)
Matiushin, Mikhail (1861–1934)
Meyerhold, Vsevolod (1874–1940)
Prokofiev, Sergei (1891–1953)
Scriabin, Alexander (1872–1915)
Serrano, Andreas (1950–)
Tatlin, Vladimir (1885–1953)
Theremin, Leo (1896–1980)

CHAPTER 7
Avraamov, Arseni (1890–c.1943)
Chagall, Marc (1887–1985)
Foregger, Nikolai (1892–1939)
Mandelstam, Osip (1891–1938)
Mayakovsky, Vladimir (1893–1930)
Shostakovich, Dmitri (1906–1975)

CHAPTER 8
Antheil, George (1900–1959)
Apollinaire, Guillaume (1880–1918)

Aragon, Louis (1897–1982)

Breton, André (1896–1966)

Buñuel, Luis (1900–1983)

Cocteau, Jean (1889–1963)

Dali, Salvador (1904–1989)

Desnos, Robert (1900–1945)

Ellington, Duke (1899–1974)

Éluard, Paul (1895–1952)

Ernst, Max (1891–1976)

Gershwin, George (1898–1937)

Léger, Fernand (1881–1955)

García Lorca, Federico (1898–1936)

Magritte, René (1898–1967)

Miró, Joan (1893–1983)

Ray, Man (1890–1976)

Riefenstahl, Leni (1902–)

Tanguy, Yves (1900–1955)

Trotsky, Leon (1879–1940)

Vaché, Jacques (1895–1919)

CHAPTER 9

Baziotes, William (1912–1963)

Benton, Thomas Hart (1889–1975)

Cowell, Henry Dixon (1897–1965)

Gorky, Arshile (1905–1948)

Graham, Martha (1894–1991)

Gropius, Walter (1883–1969)

Hofmann, Hans (1880–1966)

Ives, Charles (1874–1955)

Mondrian, Piet (1872–1944)

Newman, Barnett (1905–1970)

Noguchi, Isamu (1904–1988)

Orozco, José Clemente (1883–1949)

Pollock, Jackson (1912–1956)

Poulenc, Francis (1899–1963)

Reinhardt, Ad (1913–1967)

Rivera, Diego (1886–1957)

Rothko, Mark (1903–1970)

Schoenberg, Arnold (1874–1951)

Still, Clyfford (1904–1980)

CHAPTER 10

Burroughs, William (1914–1997)

Cassady, Neal (1926–1968)

Creeley, Robert (1926–)

Gillespie, Dizzy (1917–1993)

Ginsberg, Allen (1926–1997)

Kerouac, Jack (1922–1969)

Kesey, Ken (1935–)

Monk, Thelonious (1917–1982)

Parker, Charlie (1920–1955)

FURTHER READING

This section is designed to serve a variety of purposes. For readers who wish to see how I came to the quotations in the text, I have supplied a complete trail of references. While this may seem overly scholarly, it is useful even for casual readers. These notes provide an initial guide to further reading on the topics in the main text. In addition, the original sources are often fun to read even if you don't get every reference. And, studies of the avant-garde where I found important citations are likely to have other interesting and important information. This is true even though the books are often complex or difficult.

Many of my sources are academic books, some of which are tough going even for graduate students. I have listed them because such studies often have a rich selection of quotations and other primary sources. By browsing through the pages you can find block quotations, illustrations, and biographical details that are otherwise unavailable outside of archives. Skim the narrative and you have a treasure trove of historical information.

The notes also give me a chance to add small details and comments on the person I quote in the text or the text I used. This kind of discussion of sources is common in academic writing but less frequent in books for younger readers. While it might seem to turn clean source notes into difficult and lengthy footnotes, this discussion actually changes a dry set of page references into a more interesting conversation about the research process. And, you get to show all the neat stuff you learned that does not fit into the main story.

A useful general source for quick takes on any radical art form or artist is Richard Kostelanetz, *Dictionary of the Avant-Gardes* (Chicago: A Capella Books, 1993). A highly theoretical study which I found challenging and interesting is Renato Puggioli, *The Theory of the Avant-Garde* (Cambridge, MA: The Belknap Press of Harvard University Press, 1968).

Page 10

Saint-Simon is quoted in Linda Nochlin, "The Invention of the Avant-Garde: France, 1830–80," which appears in Thomas B. Hess and John Ashbery, eds., *The Avant-Garde* (New York: Macmillan, 1968), page 11. Nochlin is a sophisticated art historian whose book *Realism* (New York: Viking Penguin, 1971) is sure to appear in any college-level syllabus. Her writing can be tough going if you don't have a background in the field, but this collection was originally an issue of *Art News* magazine and is worth browsing through for interesting art and quotations that cover the whole history of the avant-garde.

Page 15

Shinn is quoted in Elizabeth Milroy, *Painters of a New Century: The Eight & American Art* (Milwaukee: Milwaukee Art Museum, 1991) on page 15. Though The Eight were known for their urban realism, and their approach was given the slang title of the Ashcan school, the actual exhibition contained a range of styles including Davies's metaphysical symbolism and Maurice Prendergast's almost impressionist park scenes.

Pages 16–22

All of the major English-language New York newspapers devoted a lot of space to the Armory Show. Many of their reviews, and most of their cartoons, were critical, sarcastic, or mocking. Yet looking at the papers now, you can see a spirit of innocent puzzlement and high-spirited fun in the coverage. One way to get a sense of that is to go to a library that has microfilms of old New York papers and browse through the appropriate dates. But there is also a more inclusive option. Led by the painter Walt Kuhn, the group that put on the show were good publicists and had a sense of history. They hired a clipping service to locate and send them every article about the show and kept scrapbooks of these cuttings. These offer a wonderful cross section of commentary. There are three ways to sample these resources. I found several scrapbooks at the library of the Museum of Modern Art in New York, which can be used by appointment. I combed through the letters, scrapbooks, and memorabilia in the Walt Kuhn Collection, which is available on microfilm at the branch offices of the Archives of American Art. While the actual archives are part of the Smithsonian Institution in Washington, there are branches with copies of the entire collection in major cities, which means there may be one near you. Finally, in his major history of the show, *The Story of the Armory Show* (New York: New York Graphic Arts Society, 1963) Milton Brown quotes many of these articles. If you want to check individual quotations, start with Brown. Reading

Brown will also give a more rounded sense of the challenge posed by the show. For details on the works shown, as well as more comments and cartoons, see *1913 Armory Show 50th Anniversary Exhibition 1963* (New York: Henry Street Settlement, 1963). Another view of the show, which places it in the context of an equally lively, and more explicitly political, event that occurred at the same time, is Martin Green, *New York 1913: The Armory Show and the Paterson Strike Pageant* (New York: Charles Scribner's Sons, 1988).

Page 18

Quinn was an interesting and important lawyer and collector. Though quite anti-Semitic, he had a fine sense for the new art and played an important role in helping it get established in America. For his comment on the city, see Piri Halazz, "John Quinn Collected Art and Bohemians and Recognized Great Writers and Painters When They Were Hungry." *Smithsonian,* July 1978, pages 76–84.

Page 19

Roosevelt's remark about the Navajo rug was much cited at the time and is repeated in every book or article that deals with the show. To see it in its original context, read his "A Layman's View of an Art Exhibition" in *Outlook,* March 29, 1913, pages 718–20.

Page 21

Joel Spingarn's name is remembered today, if at all, for the medal given in his honor by the NAACP. As a critic who tried to free art from all social and moral limitations, as a professor whose stand for academic freedom cost him his job at Columbia, and as a civil rights pioneer, he is an important figure who deserves to be better known. His comments appeared in the New York *Evening Post* on February 25, 1913.

Page 21

Duchamp enjoyed playing games, whether as a chess master or as a mischievous artist beguiling his critics. That means everything he said has to be viewed with some suspicion. To see this explanation of *Nude* see *Marchel Duchamp,* edited by Anne d'Harnancourt and Kynaston McShine (New York: New York Graphic Arts Society, 1973), pages 256–57.

Page 21

Street's article is probably a fictional account of a tour through the show. It has many interesting insights on the art and the crowd. See *Everybody's Magazine,* May-June 1913, pages 816–18.

Page 22

Many papers saw the link of fashion to the show. The

Evening Post suggested that "in the art collection at the Lexington Av. Armory, there will doubtless be endless aids to reflection upon spring fashions if one has eyes to see into things." The *Evening Mail* covered the Wanamakers fashion show in detail. The Gimbels cubist show is discussed by Aaron Sheon in his "1913: Forgotten Cubist Exhibitions in America," *Arts* magazine, March 1983, pages 93–108.

Page 22

I found the Dougherty cartoon in the Aline Farrelly scrapbook at MoMA.

Page 23

The reputation of Mabel Dodge Luhan has gone through various phases. Some have seen her as a path-breaking woman, others as a wealthy dabbler playing at radicalism. Most recently she seems to be coming back into favor. Whatever judgment you make of her, her book, *Movers and Shakers* (New York: Harcourt Brace and Co., 1936), is lively and interesting. For the quotation on revolt see her article, "Speculations, or Post-Impressionism in Prose," in *Arts and Decoration,* March 1913, page 172; for her description of an evening see *Movers and Shakers,* page 83. The article is especially important because it is about Gertrude Stein and links her with the art of the Armory Show. Anyone interested in the themes of this book will find much to ponder in Stein's life and work.

Pages 23–24

The Villagers of the teens are fun to read about, in part because they left so many good quotations about their hopes, dreams, and dizzy lives. One good source that is much easier to read than it sounds is Arthur Frank Wertheim, *The New York Little Renaissance: Iconoclasm, Modernism, and Nationalism in American Culture, 1908–1917* (New York: New York University Press, 1976). Like most historians of this period, Wertheim has a lot to say about the link between being rebellious and being young. For Dell and for *The Masses* see page 5; for Bourne, page 21; for Lippman, page 6. Those who want to read the radicals' own words might start with Bourne, Reed, or the early Van Wyck Brooks.

Page 24

Sloan's account of the *Arch Conspirators* can be found in Helen Farr Sloan, ed., *John Sloan New York Etchings (1905–1949)* (New York: Dover Publications, 1978). The book is unpaginated, but the comments accompany Sloan's drawing of the event, which is etching number 35.

Page 28

For a summary of the many accounts of the opening night of *Rite of Spring,* and an effort to piece them together into a portrait of what actually took place, see Modris Eksteins, *Rites of Spring: The Great War and the Birth of the Modern Age* (New York: Anchor Books, 1990), pages 10–16. The comtesse's famous quote appears on page 12. Eksteins makes many interesting associations between the ballet and the war that followed it. Some critics find these brilliant, others see them as implausible and forced. But Eksteins does show how an artistic event can be used to cast light on an entire era.

Page 28

I found the Montesquieu quotation in Cesar Grana, *Bohemian Versus Bourgeois: French Society and the French Man of Letters in the Nineteenth Century* (New York: Basic Books, 1964), page 21. This is a perfect example of how footnotes can be helpful. I discovered this book in the notes to the Seigel book cited just below. It turned out to be quite useful.

Page 30

For a description of the *Hernani* clash in the context of bohemianism and youth culture—as well as for this entire section—see Jerrold Seigel, *Bohemian Paris:*

Culture, Politics, and the Boundaries of Bourgeouis Life, 1830–1930 (New York: Viking 1986), pages 21–22. Anyone who reads that book will immediately recognize how strongly influenced by it I have been. If you are curious about anything or anyone I discuss in the chapters on France, or about the nature of the avant-garde in general, you are certain to learn much more in *Bohemian Paris.* Professor Seigel also offered helpful ideas about the issue of avant-garde and adolescence in a personal interview in the fall of 1995.

Page 31

Grana cites the famous Nerval quotation about walking his pet lobster on page 74.

Page 31

Seigel quotes Murger on page 45.

Page 32

The history of adolescence is discussed in a scholarly way, but with interesting quotations and anecdotes, in John R. Gillis, *Youth and History: Tradition and Change in European Age Relations 1770–Present* (New York: Academic Press, 1981).

Page 33

Seigel quotes Baudelaire on "vaporization" on page 266

as part of his treatment of Rimbaud. His main discussion of Baudelaire is on pages 97–124. "Concentration" appears on page 116.

Page 34

Richard Wilbur's translation of "Invitation to the Voyage" appears, with the French original, in Baudelaire, *Flowers of Evil: A Selection* (New York: New Directions, 1955), pages 52–55.

Page 36

Courbet is quoted on page 12 of Linda Nochlin's article "The Invention of the Avant-Garde: France, 1830–80," in Hess and Ashbery, eds., *The Avant-Garde,* cited above.

Page 38

For a lavishly illustrated treatment of absinthe and its place in both the culture and history of France see Barnaby Conrad III, *Absinthe: History in a Bottle* (San Francisco, CA: Chronicle Books, 1988). The book is a wonderful resource, but his effort to make a new case for the drink is at best eccentric.

Page 40

T. J. Clark's *The Painting of Modern Life: Paris in the Art of Manet and His Followers* (Princeton, NJ: Princeton University Press, 1984) is another academic book that can be used two different ways. It is one of the best examples of a school of Marxist art history and any college-level student will need to know it (which doesn't make it any easier to read). But the frequent quotations and many illustrations have something to offer even the casual reader. The "gorilla" critique is cited on page 94, the "cadaver" on page 96, the Ravenal quotation appears on pages 139–40, though Clark also refers to it earlier on.

Page 44

Edmond and Jules de Goncourt kept a journal from 1851 to 1870, when Jules died. Edmond continued to write in it until 1896, his last year. As sharp observers of life and very well connected members of the art world, the Goncourts had much to write about. If you want a personal view of anything in Paris in this period, the journal is a good place to start. The quotation about the Commune can be found in Robert Baldick, ed. and trans., *Pages from the Goncourt Journal* (New York: Penguin, 1984), page 185.

Page 45

I found helpful information on Rimbaud, as well as several key quotations, in Enid Rhodes Peschel's introduction to her translation of two Rimbaud works, *A Season in Hell: The Illuminations* (New York: Oxford

University Press, 1973). For his sense of "decomposing," see page 5, for "*voyant*," see page 7. The italics follow this translation.

Page 46

This discussion of Rimbaud, and especially the comparison with Baudelaire, is taken directly from Seigel. For the original see *Bohemian Paris,* pages 261–68.

Page 46

For Verlaine on homosexuality see Seigel, page 253. Seigel discusses the two poets' affair in the larger context of homosexuality and the avant-garde on page 244.

Pages 46–47

For Rimbaud on "disorder" see Seigel, page 265, on "formlessness," page 267. The extracts are from Peschel's translations, "Ah I suffer," page 67; "I will make gashes," page 69; "I regarded us," page 73; "I loved absurd," page 77.

Page 48

Nietzsche's views of God, Christianity, and the power of will can be found in the entry under his name in *The New Columbia Encyclopedia* (New York: Columbia University Press, 1975). For his link of art and sexuality see Geoffrey Clive, ed., *The Philosophy of Nietzsche* (New York: New American Library, 1965), page 539.

Pages 48–49

On Jarry, see Seigel, pages 310–22. Another excellent source on this period is Roger Shattuck, *The Banquet Years: The Origins of the Avant-Garde in France 1885 to World War I, rev. ed.* (New York: Vintage Books, 1968). He deals with Jarry on pages 187–251.

Page 51

Stravinsky's original image is cited in a review of an October 20, 1987, performance of Hodson's reconstruction of *Rite* that was written by Susan Manning, then a graduate student at Columbia University. She was kind enough to send me a copy of it after we attended a conference on the ballet. For a slightly different version of Stravinsky's vision see Eksteins, pages 9–10 and 39.

Page 53

This account of *Rite of Spring* is also from Manning's review.

Page 56

My interpretation of the double threat of *Rite* is neither Hodson's nor Manning's. The thrust of Hodson's work is to show that the piece was actually more similar to other dances and paintings of the time than we have thought. In seeing both the hypermodern and the ancient in it, I am as much using *Rite* as a symbol for

the cultural conflicts of its time as commenting on the actual performance people saw on-stage. For a scholarly view of the cultural implications of the new art, and especially *Rite,* see Stephen Kern, *The Culture of Time and Space, 1880–1918* (Cambridge, MA: Harvard University Press, 1983), page 124. It is no accident that Eksteins, Kern, and many others try to link the new art and the war. They were both violent disruptions of an old order that left in their wake the modern world. The great challenge is to figure out how exactly they were linked.

Page 57

We are fortunate that there is a great source book on Zurich Dada that is actually a pleasure to read. Hans Richter, author of *Dada Art and Anti-Art* (New York: McGraw-Hill, 1965), was a Dada pioneer and he brings that spirit of generous fun to the book. And yet it is also full of excellent research and valuable primary sources. Huelsenbeck is quoted on pages 20–22. For a fuller picture of New York Dada with many color photos see Francis M. Naumann, *New York Dada, 1915–1923* (New York: Harry N. Abrams, 1994). Another entry into the Dada mindset is Daniel Pinkwater's brilliant *Young Adult Novel.* Though it is fiction not history, and set in America now not in Zurich in the teens, it gives you the flavor of Dada as well as any scholarly text.

Page 58–61

Richter describes Huelsenbeck's views of music, and cites Ball's quotation, on page 20. Ball's diary is quoted on page 14. For the various meanings of Dada and stories about how it was chosen as the name of the movement see pages 31–32. Arp's comic version appears on page 32. For Ball on the war, see page 23. For Arp, turn to page 25.

Page 62

Tzara's manifesto is quoted in Roger Cardinal's entry on Tzara in Justin Whipple, ed., *Makers of Modern Culture,* (New York: Facts on File, 1981), pages 529–30. I found Whipple's book to be a useful source for brief citations on many key twentieth-century thinkers. He favors Europeans, and the entries tend to have a somewhat dated social-critical slant. Still, books like this are a good place to start one's research.

Pages 62–63

Richter quotes Ball on simultaneous poetry on page 31, and on Kandinsky and synesthesia on page 35.

Page 64

De Casseres is quoted in William Agee, "New York Dada, 1910–30," which is one of the articles in Hess and Ashbery, *The Avant-Garde,* cited above. The piece

runs from page 105–13, and the quotation is on page 107.

Page 65

Richter quotes Ball on chance on page 49.

Page 66

Einstein's well-known statement is often quoted or paraphrased. For his exact words see Gerald Holton, *Thematic Origins of Scientific Thought, Kepler to Einstein* (Cambridge, MA: Harvard University Press, 1973), page 120. Holton is a historian of science and anyone who wants to see a sophisticated discussion of the Bohr-Einstein conflict in a larger historical frame should read the entire chapter, "The Roots of Complementarity," on pages 115–61.

Pages 66-68

A very readable introduction to Duchamp, based on interviews with him, can be found in Calvin Tomkins, *The Bride and the Bachelors: Masters of the Avant-Garde: Duchamp, Tinguely, Cage, Rauschenberg, Cunningham* (New York: Viking Penguin, 1968, pages 9–68). Along with Richter, it is the best place to begin studying the avant-garde. Tomkins has recently published a full-scale biography titled *Duchamp* (New York: Henry Holt, 1996) that is filled with interesting insights and tales. For a

much more academic treatment that tackles Duchamp's brilliant gamesmanship on its most abstract level see Jerrold Seigel, *The Private Worlds of Marcel Duchamp: Desire, Liberation, and the Self in Modern Culture* (Berkeley, CA: University of California Press, 1995).

Page 70

Most sources on Malevich and the Russian avant-garde are wonderful to look at but terribly frustrating to read. That is because, until the fall of Communism, judging his tangled relationship with the Soviet state also meant judging the Soviet Union and Communism. Anti-Soviet historians dismissed the art, while those concerned with defending Soviet Communism had to explain away the terrible actions of the state. A perfect example is the set of articles in the phenomenal catalog to the exhibition *The Great Utopia: The Russian and Soviet Avant-Garde, 1915–1932* (New York: Guggenheim Museum, 1992), which was mounted by an international group of four museums. This unparalleled source of reproductions and quotations is burdened with an almost totally unreadable text. For the show's title, see Jane A. Sharp, "The Critical Reception of the 0.10 Exhibition: Malevich and Benua," pages 38–52. A poster for the show with a translated caption appears on page 38.

Page 70

On Marinetti see Caroline Tisdall and Angelo Bozzolla, *Futurism* (New York: Oxford University Press, 1978), page 8. The fascinating illustrations make this an exciting book for any reader.

Page 71

I found this *zaum* poetry in Douglas Kahn and Gregory Whitehead, eds., *Wireless Imagination: Sound, Radio, and the Avant-Garde* (Cambridge, MA: MIT Press, 1994). This is an edited volume and some of the pieces are more academic than others. But anyone curious about the many unusual ways sound, sound recording, and sound transmission have been used by avant-garde artists will enjoy browsing through the book and discovering some of the truly strange and original minds of this century. Kruchenykh's poem is quoted on page 212 in Mel Gordon, "Songs From the Museum of the Future, Russian Sound Creation (1910–1930)," pages 197–243. Khlebnikov's speech appears in the same article on page 217.

Pages 72–75

Lissitzky is quoted in the Sharp article in the *Great Utopia* book cited above, on page 39. The complete capitalization of "suprematism" follows the original. Benois (whose name Sharp transliterates as Benua) is quoted on "blasphemy," "machinishness," and "death" on page 42. His accusation of "arrogance" is on page 43, and Malevich's response on page 44. Lissitzky on the link between constructivism and Communism also appears on page 39.

Pages 76–79

Lenin is quoted in Richard Pipes, *The Russian Revolution* (New York, Alfred A. Knopf, 1990), page 689. Blok can be found in Richard Pipes, *A Concise History of the Russian Revolution* (New York: Alfred A. Knopf, 1995) on page 55. The underlining appears in the original. Pipes is very critical of Lenin, Communism, and the Soviet Union. This makes him unpopular with some critics and too simplistically critical of Soviet art, but he is thorough and was one of the first to make use of the resources available after the fall of the Communist state. His history is the best place to start research on these events. Lenin's effect is described by a man who was there on page 117. His desire to "smash" the "machine" appears on the following page.

Page 79

An excellent overview of the history of the avant-garde that is filled with color reproductions is Robert Hughes, *The Shock of the New* (New York: Alfred A. Knopf, 1980). Consulting Hughes while reading this

book will give you a chance to see many of the works I discuss in color. Lunacharsky is quoted on page 87.

Page 80

Any discussion of Meyerhold is sure to mention his "biomechanical" theories. I used the entry by Dr. John Milner in Whipple, *Makers,* see pages 354–55.

Page 82

To give the futurists credit, they were not so much against women as against what they saw as sentimental and repressive Victorian femininity. They thought such attitudes harmed both men and women. Still, their emphasis on virility, violence, and war did contain antifemale, not just antifeminine, strains. The quotation can be found in *Futurism,* page 153.

Page 85

For a brief discussion of Theremin see Gordon in *Wireless Imagination,* pages 235–37.

Page 91

Ian MacDonald, *The New Shostakovitch* (London: Fourth Estate, 1990), uses the composer's posthumous revelations as a prompt to reexamine all of his compositions. When it was written there was still some doubt about the authenticity of the words attributed to Shostakovitch. That is no longer the case. For the robot image see page 123.

Page 88

Charlotte Douglas, *Malevich* (New York: Harry N. Abrams, 1994), is aimed at a broader audience than the Guggenheim catalog and has many excellent historical photos and color plates. Douglas quotes the Soviet criticism of the artist on page 33.

Page 91

MacDonald quotes Shostakovich on "rejoicing" on page 126.

Page 93

Much of the French avant-garde runs through Erik Satie. For an excellent insightful look at Satie that includes detailed discussions of his music see Shattuck, pages 113–85. Even if you cannot read music or follow the convolutions of Satie's elaborate games, you can get a sense of how humorous and strange he was just by listening to his compositions. Seigel, who also has much to say about Satie, discusses the connection between *Parade* and *Rite* on pages 360–63.

Page 94

On Breton and surrealism see Mark Polizzotti,

Revolution of the Mind: The Life of André Breton (New York: Farrar, Straus and Giroux, 1995). Being Breton's biographer is a tough challenge, since there is much to admire and to criticize in his life. Depending on your own view of Breton and surrealism, you may find Polizzotti either too kind or too critical. But he has done diligent research and written a readable account that allows the rest of us to judge for ourselves. For the story of Exquisite Corpse see page 258. The Guggenheim quotation appears on page 176.

Page 95

On the poetry of mad soldiers see Polizzotti, page 31. *Moldoror* is quoted on page 73. Breton's dream appears on page 103, and uncontrolled thought on page 209.

Page 100

Breton on revolutionary action is from Polizzotti, page 242. His hopes for the end of Western civilization can be found on page 237. For a detailed scholarly study on this subject see Alan Rose, *Surrealism and Communism: The Early Years* (New York: Peter Lang, 1991).

Page 102

Gershwin's aims are cited in the Wilfred Mellers' entry on him in *Makers,* see pages 191–93.

Pages 104–5

The standard history of this period of American art is Irving Sandler, *The Triumph of American Painting: A History of Abstract Expressionism* (New York: Harper & Row, 1970). Sandler knew the artists and includes many revealing quotations and anecdotes, as well as a good selection of black-and-white reproductions. His view of the period is indicated by the title of his book. He places the artists at the center of his study and puts politics and culture on the margin. More recently, Serge Guilbaut, *How New York Stole the Idea of Modern Art: Abstract Expressionism, Freedom, and the Cold War* (Chicago, University of Chicago Press, 1983), has argued that Cold War politics, as much as artistic talent, lay behind whatever "triumph" took place. Guilbaut's specific argument is unconvincing, at times even ludicrous, but he does begin to link the art and its time in thought-provoking ways. Sandler quotes Baziotes on page 72. Robert Hughes's latest book, *American Visions* (New York: Knopf, 1997) came too late for me to use. But both it and the PBS TV series based on it are filled with excellent images and provocative insights on American art.

Page 106

Mondrian's theosophical ideas are quoted in Susanne Deicher, *Piet Mondrian: Structures in Space* (Cologne,

Germany: Benedikt Taschen, 1995), on page 25. Like all of the Taschen art books, this short introduction to Mondrian is informative, readable, and filled with color reproductions.

Page 107

My understanding of Mondrian was greatly enhanced by a visit to a MoMA exhibition of his works with the artist Chris Raschka. Raschka's sensitivity to Mondrian's brush strokes entirely changed my view of the paintings.

Page 110

Ives's instructions are cited in Jan Swafford, *Charles Ives: A Life in Music* (New York: W.W. Norton, 1996), on page 167.

Page 111

I was introduced to President Eisenhower's quotation while editing Steven Jaffe's book, *Who Were the Founding Fathers* (New York: Henry Holt, 1996).

Page 111

Sandler quotes this definition of "ideograph" on page 148.

Page 112

For Pollock on Native American art, see Claude Cernuschi, *Jackson Pollock: "Psychoanalytic" Drawings* (Durham, NC: Duke University Press, 1992), on page 6. This oversize volume reproduces the drawings Pollock made during his analytic treatments. They are the essence of nightmare.

Page 115

Pollock on the origin of *She-Wolf* can be found in the catalog to the exhibition "Jackson Pollock Paintings and Drawings 1934–1952," published by the Anthony d'Offay Gallery (London, 1989).

Page 116

Sandler quotes Pollock on his drip paintings on page 93. The block quotation appears on page 102.

Page 116

An insightful discussion of Pollock the man and the myth, which also features excellent photographs of him painting, is Brian O'Doherty, *The Voice and the Myth: American Masters* (New York: Universe, 1988). O'Doherty cites Pollock's quotation on nature on page 106.

Page 118

The claim that *Quintet* records the greatest jazz concert

ever appears on the liner notes to the Debu Records CD [OJCCD-044-2 (Deb-124)] as a quotation, but without attribution.

Page 118

For a short summary of some issues in the history of bebop see chapter 10 of Gunther Schuller, *The Swing Era: The Development of Jazz, 1930–1945* (New York: Oxford University Press, 1989). My thanks to Ben Ratlief for bringing this to my attention.

Page 118–19

Creeley's letter is quoted in David Meltzer, ed., *Reading Jazz* (San Francisco, CA: Mercury House, 1993), on page 224. This is a good place to start if you want to browse through all of the prose and poetry jazz has inspired.

Page 119

Kerouac's lines are part of the 239th chorus of his *Mexico City Blues* (New York: Grove Press, 1959), page 241.

Page 119

For the origins of the term "beat" see Steven Watson, *The Birth of the Beat Generation: Visionaries, Reels, and Hipsters, 1944–1960* (New York: Pantheon, 1955), pages 3–4. This is an easy introduction to the beats and their times, including a time line, handy facts, and many pictures. It is like a tourist guide to an historical era. For a collection of beat poetry aimed at younger readers see David Kherdian, ed., *Beat Voices* (New York: Henry Holt, 1995).

Page 120–21

For "candles" see *On The Road* (New York: Penguin, 1979), page 8. For "joy," page 10. For the extract, see page 180. The Carlo Marx lines are on page 119.

Page 121

Kerouac's account of "Howl" in his *Dharma Bums* is quoted in the notes to Ann Charters, ed., *Jack Kerouac: Selected Letters, 1940–1956* (New York: Viking, 1995), page 524. His letter to Holmes appears on the same page.

Chapter 11

For a brilliant description of the sixties, as seen through a thorough examination of all of the Beatles' recordings and recording sessions, see Ian MacDonald, *Revolution in the Head* (New York: Henry Holt, 1994). MacDonald captures the crackpot optimism of the era better than any writer I've come across.

Pages 123–25

This description of Woodstock is an impressionistic amalgam of legend, memory, and repeated viewings of the movie *Woodstock*. In the event, dress and undress were more varied, and in some cases more conventional, than this suggests.

Pages 125–28

Unfortunately this chapter relies more on memory and general knowledge than sources you can consult. One interesting way to start a study of the era would be to read through the relevant issues of a magazine such as *Rolling Stone* or *Ramparts* that sought not only to report the events of the decade but to incarnate its spirit in tone, attitude, focus, and design. A sampling of underground papers, like those mentioned in the text, or the Berkeley *Barb*, Boston *Phoenix*, or whatever variant is available in a local library, would serve just as well. Be sure, though, to pay as much attention to ads, personal columns, typography, and art as to the words. That would give a more rounded picture of the times than you would get by concentrating on the causes featured in the columns.

For a summary of all of the sixties' challenges see William L. O'Neill, *Coming Apart: An Informal History of America in the 1960's* (Chicago: Quadrangle Books, 1971). O'Neill is critical of much of the ferment of this era, but he is a thorough historian and covers all of the key topics and events.

An insider's history of the sixties by a radical political leader who became an accomplished historian is Todd Gitlin, *The Sixties: Years of Hope, Days of Rage* (New York: Pantheon, 1987). An interesting study of rock, youth, culture, and consumerism in this period is Simon Frith, *Sound Effects: Youth, Leisure, and the Politics of Rock 'n' Roll* (New York: Pantheon, 1981). Just now, what actually happened in that decade is being reinterpreted by a new generation of scholars. For a handy summary of this generation gap in writing about the generation gap, see Rick Perlstein, "Who Owns the Sixties?" in *Lingua Franca*, May-June 1996, pages 30–37.

Page 130

The description of Cage's TV triumph is from *The Bride and the Bachelors*, pages 130–33.

Page 132

References to this archetypical expression of the generation gap were universal at the time. It was first said by Jack Weinberg during the free speech protests in Berkeley, California.

Page 132

The best-known account of the Pranksters was Tom Wolfe's *The Electric Kool-Aid Acid Test* (New York: Farrar, Straus and Giroux, 1968)

Page 134

While searching in the library for photo sources I discovered Sally Banes's useful study, *Greenwich Village 1963: Avant-Garde Performances and the Effervescent Body* (Durham, NC: Duke University Press, 1993). Coincidentally, she, too, begins in Washington Square and takes her readers on an imaginary tour of the Village, this time in 1963. Though she does this to point out specific places and the kinds of art that went on there—not to contrast two different ways of experiencing the walk—her book adds yet another dimension to the Hendrix-Cage trips I outline here. See pages 20–23.

Page 136

Tomkins quotes Cage on sound in *The Bride and the Bachelors* on page 101.

Page 136

"Purposeless games" appears on page 73 of Tomkins.

Pages 138–39

The art historian Caroline Jones was kind enough to send me a copy of an article in which she raises the question of the relationship between Cage's art and his sexuality. She sees his focus on silence, and refusal to have any distinct meaning for his work, as a direct counter to the hypermacho abstract expressionists. However hidden, then, his homosexuality was part of the meaning of his life and art. This is a difficult academic piece, but worth reading for anyone who really wants to study Cage. See "Finishing School: John Cage and Abstract Expressionist Ego" in *Critical Inquiry*, Summer 1993, pages 628–65.

Page 147

Cage on redoubled efforts can be found in Tomkins on page 107.

Pages 145–47

For a clear history of pop and other art developments in this period see Barbara Rose, *American Art Since 1900,* revised and expanded ed. (New York: Praeger Publishers, 1975). My thanks to Jack Macrae for lending me this book.

Pages 148–51

This history of punk is drawn from Jon Savage's excellent *England's Dreaming: Anarchy, Sex Pistols, Punk Rock, and Beyond* (New York: St. Martin's Press, 1992).

The book combines personal experiences with broad social insights and a detailed, even day-by-day, history of the Sex Pistols. It also has many unusual photos that would otherwise be very difficult to find. All three graffiti appear on page 111. Greil Marcus, *Lipstick Traces: A Secret History of the Twentieth Century* (Cambridge, MA: Harvard University Press, 1989), takes punk and the Sex Pistols as a pivotal event in this century that has links with all of the other avant-garde movements we have discussed.

Pages 152–53

Savage's fascinating account of the "God Save the Queen" boat ride and scandal interweaves lyrics from the song with a blow-by-blow description of the affair. It can be found on pages 351–67.

Pages 154–59

The title for this section is quoted from a Guerilla Girls poster that is reprinted in Brandon Taylor, *Avant-Garde and After; Rethinking Art Now* (New York: Harry N. Abrams, 1995), on page 13. This book has many color reproductions of recent artworks, a time line of art, politics, and surrounding culture from 1972 to 1994, as well as a handy summary of movements and controversies in that period. Written by an English author, though, it skips the political fights over art, censorship, and public taste that have been so important in America since 1989.

Pages 161–62

The controversy over *Still/Here* began when the dance critic Arlene Croce refused to see it, but pointed out the problems the piece raised in an article titled "Discussing the Undiscussable" in the *New Yorker* (Dec. 26–Jan. 2, 1995), pages 54–60.

Page numbers in *italics* refer to illustration or caption.